RHINEBECK'S
HISTORIC
ARCHITECTURE

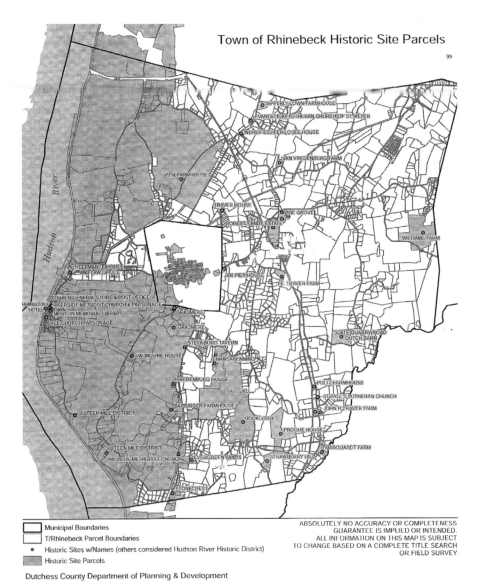

SIPPERLY-TOWN FARMHOUSE
EVANGELICAL LUTHERAN CHURCH OF ST. PETER
NEHER-ELSIFER-LOSEE HOUSE
I. VAN VREDENBURG FARM
COX FARMHOUSE
TRAVER HOUSE
THE GROVE
ROBERT SANDS ESTATE
WILLIAMS FARM
HEERMANCE HOUSE AND LAW OFFICE
JAN PIER HOUSE
E. TRAVER FARM
O'BRIEN GENERAL STORE & POST OFFICE
RHINECLIFF RIVERSIDE METODIST CHURCH & PARSONAGE
HOTEL MORTON MEMORIAL LIBRARY
GRASMERE
FREE CHURCH-PARSONAGE
GRASMERE
SLATE QUARRY ROAD DUTCH BARN
STEENBURG TAVERN
J. W. MOORE HOUSE
MANSAKENNING
FREDENBURG HOUSE
PULTZ FARMHOUSE
KEL
ST. PAUL'S LUTHERAN CHURCH
BARRINGER FARMHOUSE
JOHN H. TRAVER FARM
SIXTEEN MILE DISTRICT
ROCKLEDGE
PROGUE HOUSE
MARQUARDT FARM
SIXTEEN MILE DISTRICT
HILLSIDE METHODIST CHURCH
EVERGREEN LANDS
STRAWBERRY HILL
STONECREST

River
Hudson

☐ Municipal Boundaries
☐ T/Rhinebeck Parcel Boundaries
● Historic Sites w/Names (others considered Hudson River Historic District)
▨ Historic Site Parcels

Dutchess County Department of Planning & Development
December 2004
Map Not to Scale

Courtesy Dutchess County Department of Planning.

RHINEBECK'S
HISTORIC
ARCHITECTURE

NANCY V. KELLY

Charleston London

THE
History
PRESS

Published by The History Press
Charleston, SC 29403
www.historypress.net

First published 2009

Manufactured in the United States

ISBN 978.1.59629.606.0

Library of Congress Cataloging-in-Publication Data

Kelly, Nancy V.
Rhinebeck's historic architecture / Nancy V. Kelly.
p. cm.
Includes bibliographical references and index.
ISBN 978-1-59629-606-0
1. Architecture--New York (State)--Rhinebeck. 2. Historic buildings--New York (State)--
Rhinebeck. 3. Rhinebeck (N.Y.)--Buildings, structures, etc. I. Title.
NA735.R48K45 2009
720.9747'33--dc22
2008055292

This book is dedicated to all who have worked to preserve Rhinebeck's historic character.

CONTENTS

National Register Listings 9

Acknowledgements 11

Introduction 13

Chapter 1 The Spirit of Rhinebeck 15

Chapter 2 Colonial Stone Houses, 1700–1775 21

Chapter 3 Colonial Frame Houses, 1740–1810 45

Chapter 4 Georgian, Federal Houses, 1790–1840 55

Chapter 5 Greek Revival Houses, 1830–1845 71

Chapter 6 Gothic Revival Houses, 1842–1870 89

Chapter 7 Italianate Houses, 1852–1877 109

Chapter 8 Second Empire Houses, 1871–1880 123

Chapter 9 Late Victorian Houses (Queen Anne, Eastlake,
Shingle), 1888–1914 133

Chapter 10 Eclectic Houses (Tudor, Spanish Revival, Beaux Arts,
Craftsman), 1880–1948 143

Epilogue 167

Notes 169

Bibliography 175

Index 181

About the Author and the Photographer 189

National Register Listings

Awareness of the unique architectural structures in Rhinebeck, New York, and an interest in historic preservation have led to town and village surveys and listings on the National and State Registers of Historic Places for individual buildings and for several districts of structures and sites. Codes used in the book are given below and identify the listing of the buildings on the National Register.

The descriptions of buildings used on nomination forms are often reproduced in the sections about individual buildings provided in this book.

Types of listings are shown below with the abbreviation used in this book shown in boldface type.

NR—National Register individual listing. In 1973, the Delamater House (#73001185) was the first building listed, followed in 1975 by the Robert Sands House site (#75001183). The Evangelical Lutheran Church of St. Peter (#75001182), with parsonage and schoolhouse, was also listed in 1975. Finally, in 1989 the U.S. Post Office received an individual listing, and in 2001 the Neher-Elseffer-Losee House, known as the Palatine Farmstead on Route 9, was listed.

Village District—The Rhinebeck Village Historic District (#79001578) was described and listed in 1979. It covers 1,670 acres and 272 buildings.

The Sixteen Mile District (#79001571) was listed in 1979. Beginning in Germantown and extending to Staatsburg, it includes estates along the Rhinebeck shoreline on the Hudson.

Landmark District—The National Historic Landmark District (#90002219), recognized in 1990, includes the Sixteen Mile District. This

district also includes Rhinecliff and records 1,402 buildings, 382 structures and 3 objects.

Multi-R District—A Multi-Resource District was declared in 1987 for selected buildings in the town and village of Rhinebeck, including some in the hamlet of Rhinecliff.

Acknowledgements

A special thanks is due my husband, Arthur Kelly, whose books of Rhinebeck records have been invaluable in compiling this study. Much appreciation is due Tom Daley for the multitude of photos he has taken portraying Rhinebeck buildings and for his generosity in sharing them for this book. Thanks also to Kay Verrilli, persistent advocate of preservation and town planning, who has been of great assistance; and to all those who have shared local history and architectural knowledge and provided suggestions to improve the manuscript, especially to John Winthrop Aldrich, New York State Deputy Commissioner for Historic Preservation, Warren Temple Smith, AIA, and Elma Williamson, local historian. Special inspiration has been found in my daughter Clare Lise Kelly's work in historic preservation and her book, *Places from the Past: Montgomery County, Maryland*.

INTRODUCTION

The architecture of Rhinebeck is the tangible representation of its history. To appreciate its significance, we must become acquainted with the builders and early owners of the structures and visualize their lives and influence. If we study the houses in the context of their architectural styles and the time periods in which they were built, we will see that each building was influenced by the economic circumstances of its owner, which were then reflected in the size, shape and function of the building. The architect or builder is seen, leaving his imprint on the house in many ways.

National Register descriptions of the earliest eighteenth-century stone houses evince a difference in construction between the German and Dutch houses. The Dutch built the first houses in Rhinebeck. The Germans, who came only a decade or two later, adopted some of their building methods and added their own variations. The difference in construction methods will be noted in the discussion of individual stone houses.

Study reveals that in the nineteenth century the owners of the river estates possessed the means to employ architects and builders, introducing the latest style of building to modify or replace the earlier vernacular structures. The craftsmen who were employed on the river mansions learned new techniques and styles and soon adopted and reproduced them for the use of the townspeople.

Many houses have not been included in this book because their original style is no longer discernable or because they were not originally built in the style they presently exhibit. The practice of upgrading older, more modest, buildings to the fashionable taste of the period visibly reflected the owner's economic situation.

The large number of historic structures in Rhinebeck also makes it impossible to include all significant houses in this book. Hundreds of houses listed on the National Register of Historic Places have been omitted, while

other historic houses are included that were not eligible for registry because of aluminum siding or major façade change but are nevertheless significant historic structures. Examples of major styles of architecture have been chosen, and occasional ghosts—buildings no longer extant—are included because of their significance and influence on Rhinebeck's architecture and history.

Although all buildings cannot be pictured in this book, many of them are visible from a public roadway. When possible, addresses are listed to allow readers to view the buildings.

When National Register nominations were prepared, several types of information were not available for use. Manuscripts now available enable much better understanding of the structures. Historic maps, prepared circa 1802–3, provide us with detailed information about leaseholders in many areas of Rhinebeck. Rent books and account books from the Beekman/ Livingston landholdings clarify early land use patterns. A series of survey maps in the Teal Collection provide details of early twentieth-century land development. These maps have been inventoried by Michael Frazier of the Rhinebeck Historical Society and scanned by the Consortium of Rhinebeck History. The consortium also provides an online database of manuscript holdings of its members, the area historical organizations.

THE SPIRIT OF RHINEBECK

In 1907, over a century ago, the poet Joseph T. Hammick, recognizing Rhinebeck's beauty and eulogizing the historic qualities of the village, published "Rhinebeck the Beautiful." Through the efforts of many people, we still boast of these qualities today.

Throughout the centuries, there have been benevolent spirits in Rhinebeck. They are the ghosts of those who devoted their time, energy and resources to make Rhinebeck what it is today. We pay homage to the Rhinebeck citizens who exhibited pride in their community, recognized its beauty and historic qualities and sought to help preserve them.

The spirit of Rhinebeck is paramount in the town's original large landholder, Henry Beekman. He was instrumental in naming the town, settling it and building its first mill. We can trace his pride in the land, continuing through his son, Colonel Henry, who donated land for the Rhinebeck Reformed and St. Paul's Lutheran Churches. This spirit also continued through the beneficence of Colonel Henry's descendants. His granddaughter, Catherine Livingston Garrettson, was as generous to the Methodist Episcopal Church as was her daughter, Mary Garrettson, while her cousins—the Suckleys and the Astor and Delano descendants—contributed to the Church of the Messiah.

Janet Livingston Montgomery's will declared her brother, Edward, her heir. He inherited a large portion of Rhinebeck Village. His widow, Louise, thought that she could be beneficial by selling the land to the Rhinebeck Improvement Company, with stockholders William B. Platt, John T. Schryver, Freeborn Garrettson, Rutsen Suckley, John Armstrong Jr. and Walter Cunningham, for $19,600.[1] Unfortunately, John T. Schryver, a large stockholder, had an obstructionist view of improvement. He situated his own house so that it blocked the extension of Livingston Street beyond Mulberry Street. Luckily the village grid was eventually extended, but only after a bitter court fight.

Toward the end of the nineteenth century, leading citizens of the town formed the Rhinebeck Realty and Development Company, which strove to protect Rhinebeck Village from the land acquisition practices of John Jacob Astor at Ferncliff. At that time, Astor was buying farms between his Ferncliff estate and the village of Rhinebeck and was systematically burning or demolishing the buildings to create green space for his estate. The development company was deeply concerned about the future of Rhinebeck as the Astor land encroached ever closer to the village.

The Rhinebeck Realty and Development Company included prominent citizens Dr. George N. Miller, R. Raymond Rikert, Theodore Delaporte, Frank Herrick and Thaddeus J. Herrick.[2] Their objective was to provide an alternative to Astor for any Rhinebeck citizens needing to sell their property. The property was bought by the development company and used in ways beneficial to the town. They made it possible for individuals to purchase their own homes and also lent money where necessary for repairs or the building of a new house.

This was before zoning and land use planning became common practices. Nevertheless, the principles involved in good land stewardship were self-evident to these civic-minded citizens. Benson R. Frost, a leading attorney, became an active stockholder in the company. His influence resulted in the location of the Dutchess County Fairgrounds in Rhinebeck and in the donation of company property for the location of the Northern Dutchess Hospital.

In his capacity as editor of the *Rhinebeck Gazette*, Jacob Strong included a section on the editorial page of every newspaper outlining Rhinebeck's attributes and suggesting improvements that should be made in Rhinebeck. His spirit is preserved in those issues of the paper, indicating how he contributed toward town pride and improvement.

Early in the twentieth century, Tracy Dows became a leading civic-minded citizen. In 1909, he employed architect Harrie T. Lindeberg to design the Dows mansion, Fox Hollow, overlooking the Hudson. Apparently, Mr. Dows found the design was so successful that he hired Mr. Lindeberg to renovate the venerable Beekman Arms at the main crossroads in the Rhinebeck Village to achieve a similar effect. The hotel had undergone various transformations from the original gambrel-roofed stone tavern of colonial times, acquiring two levels of Victorian porches. Mr. Lindeberg's design provided Rhinebeck with a signature building at its very center. In many respects it became the symbol of Rhinebeck.

Mr. Dows collaborated with Helen Delaporte, founder of the local chapter of the Daughters of the American Revolution (DAR), by providing

photographic documentation of many of Rhinebeck's important buildings. This served to increase pride in the buildings and offers us a record of buildings that have since disappeared. From 1917 to 1927, Mrs. Delaporte and the members of the Chancellor Livingston Chapter of the DAR expended a great deal of effort in researching and writing histories of Rhinebeck's important early buildings at a time when early descriptions of the properties could still be obtained.

Homer Staley (1912–1996), whose family had deep roots in Rhinebeck, was a real estate agent who also had a great concern for Rhinebeck's future. In 1963, he was responsible for the establishment of Ferncliff Forest Preserve when Vincent Astor's widow, Brooke Astor, disassembled the Ferncliff estate. He was also instrumental in the establishment of zoning in Rhinebeck and was the first chairman of the Rhinebeck Planning Board, serving for ten years until 1971.

The beloved spirit of local pharmacist DeWitt Gurnell (1907–1998) may be found in many aspects of Rhinebeck life. He organized a Drum and Fife Corps and a Young Historian's Club and initiated the founding of the Rhinebeck Historical Society. He became Rhinebeck's first official municipal historian. His early work in preservation focused on the revitalization of downtown Rhinebeck, encouraging a study by Cornell University students that resulted in a plan for the beautification of the business district and the planting of street trees prior to the bicentennial of the country.

Rhinebeck's second Town Historian, architect Richard Crowley (1930–1992), left an indelible imprint on documents now at the Library of Congress. Dick was instrumental in the Historic American Buildings Surveys (HABS) conducted in Rhinebeck during the time when he was president of the Rhinebeck Historical Society. Many important houses in Rhinebeck were surveyed. The results of this work may also be seen on the Library of Congress's American Memory website.

John Poppeliers, writing for the National Historic Trust, said, "The first HABS drawings were produced by architects, and the fact that so many of their sheets resemble actual working drawings…reflects their intention that they be used."[3] The study documents many important buildings within the town.

In the mid-1960s, Dick Crowley organized and supervised a comprehensive survey of the more than three dozen historic estates between Staatsburg in Dutchess County and Clermont in Columbia County. The survey led to the successful nomination of a one-mile-wide, sixteen-mile-long district for the National Register of Historic Places in the mid-1970s and in 1990 to the area's designation as the Hudson River National Historic Landmark District.[4]

In 1973, as the building of an eight-hundred-unit residential development on Rhinebeck's prized estate lands became imminent, four housewives —who would become known as "the Four Fighting Ladies"—headed a well organized resistance to the project's approval. Jane Gallow, whose spirit still lingers, along with Sally Mazzarella, Dorie McKibbin and Kay Verrilli, encouraged citizens to educate themselves about the proposal and to speak out about their feelings. A reported eight hundred people attended the public hearing, and no one but the developer's staff spoke in favor of the project.

As a result of their efforts, Jane Gallow was voted to the Rhinebeck Town Board, Dorie McKibbin was appointed to the Rhinebeck Village Planning Board, Kay Verrilli joined the Town Conservation Advisory Committee and Sally Mazzarella became chairman of the Rhinebeck Town Planning Board, maintaining that position for twenty years. Sally has continued to be active in town planning issues, recently serving as chairman of the Town Comprehesive Plan Committee. Countless volunteer hours supplied by Mrs. Mazzarella and other citizens of the town have contributed to Rhinebeck's reputation for exemplary planning.

Marilyn and John Hatch's service to preservation in Rhinebeck is commemorated by a plaque at the Quitman House, a former parsonage that they saved from destruction, which led to the founding of the Quitman Resource Center for Preservation, a center for restoring and maintaining the house and providing preservation information to the community. Marilyn instituted the survey of Rhinebeck Village buildings, resulting in the 1979 nomination of 272 buildings as the Rhinebeck Village Historic District. She also organized the work that, in 1987, resulted in the National Register Multi-Resource District for the town. In 2001, Marilyn and John became interested in the fate of the eighteenth-century Neher-Elseffer House. When the property came under the care of the Quitman Center, Marilyn and John organized the Palatine Farmstead Committee with representatives from various preservation groups in the area. The Farmstead Committee has made substantial progress in the restoration and preservation of the house and barn on the property as a means of interpreting Palatine settlement in Rhinebeck.

J. Winthrop Aldrich, a descendant of the Livingston (and the Beekman) family, has contributed in innumerable ways. He was a founder of the preservation organization Hudson River Heritage in 1974 and in 1990 played a major role in establishing the Hudson River National Historic Landmark District, which extends for twenty miles along the river north from Hyde Park. This work contributed, in turn, to congressional enactment of the Hudson River Valley National Heritage Area in 1996.

Wint served as president of the Hudson River Conservation Society (1974–84), facilitating its evolution into today's Scenic Hudson Land Trust, and he was the founding president of Wilderstein Preservation in Rhinebeck (1980–88), devoted to restoring and managing a notable nineteenth-century country seat. Since 1975, he has been the Red Hook Town Historian.

In 1968, Arthur C.M. Kelly began assembling local information, commencing with the baptism and marriage records of St. Peter's Lutheran Church (Stone Church). In the years since then, he has prepared many books of various types of Rhinebeck records, including information contained in church, road, cemetery and census records. His efforts in transcribing and indexing copies of this valuable information provide genealogists and historians with easy access to the secrets of the past.

Modern evidence of this spirit of concern and benevolence is found among those who have donated land conservation easements. This is a more recent concept, offering a means to provide open space that will enhance significant architecture and contribute to the unique atmosphere and rural character of the town while retaining ownership and use of the property.

The Winnakee Land Trust was incorporated in 1989. Its stated mission is "to protect and preserve the natural agricultural, recreational, architectural, cultural, scenic, historical, and open space resources of northern Dutchess County."

Untold volunteer hours devoted to planning and zoning by the various town and village board members can never be suitably recognized. Historic Rhinebeck remains vibrant through their efforts.

Hope for Rhinebeck's future rests on this tradition of concern evidenced in the past and the expectation that the concern of future citizens will continue to provide for Rhinebeck's future by remaining sensitive to this past.

COLONIAL STONE HOUSES, 1700–1775

S ettlers on the Rhinebeck patents came from various backgrounds. The first patentees were Dutch, their families having settled New Amsterdam. Some French Huguenots from New Paltz (settled in 1678), Ulster County, became early residents. Germans, known as the Palatines, came to America in 1710 and were followed by emigrants from the Württemberg area of Germany. English and other nationalities were represented less frequently in the colonial population of Rhinebeck.

By studying the site of an early Rhinebeck stone house, one can begin to appreciate the simple colonial lifestyle. The house may be situated near a spring or a stream, providing a ready source of water, although in many areas of Rhinebeck a shallow well could be dug to serve the same purpose. Settlement at the house site probably began with a dugout structure built into a hillside. The origins of the house may often be found by looking at the basement level. There are a few documented cases of log houses, but most often settlers in Rhinebeck started the house by digging into a hillside.

The first phase involved building stone sides and a roof to accommodate the family, while major effort was given to clearing land and erecting a barn. The original part of the construction had a fireplace and "climate control" through the dirt surrounding the two or three walls of the structure built below grade. This large room would later serve as the kitchen for the house, cool in summer and warm in the winter. The original door provided a grade-level entrance. As soon as possible, the house was expanded, usually to one first-floor room and a garret. A door to the upper part of the house opened from the higher level of the site and then became the main entrance. The family may have been accommodated in this structure for a generation with the older children sleeping in the garret.

Colonial families were very large. Studies of Palatine and Dutch families show that many women continued bearing children on a regular basis

throughout their productive adult lives. Thus families of ten to twelve children often occupied these homes. All were expected to contribute to the family's welfare. Girls helped with cooking, gardening and clothing manufacture, while the boys worked in the barn and on the fields of the farm. Eventually, the house would be enlarged, often to accommodate the family of a married son. Many souls left their imprints on these houses. Careful examination of colonial homes will reveal their history of expansion.

Helen Wilkinson Reynolds provided an excellent study of Dutchess County homes in her book *Dutch Houses in the Hudson Valley Before 1776*. This book includes two plates, showing houses that stood on the west side of Route 9 in Rhinebeck. Miss Reynolds also wrote *Dutchess County Doorways and Other Examples of Period Work in Wood, 1730–1830*, in which she discusses period doors, including the typical "Dutch door," which was made in two parts with a horizontal break, allowing the lower portion to remain closed to keep toddlers in and farm animals out, while the upper portion could be left open for air. Stones for construction were readily available and were used as they were found, with little attempt to square or quarry them. Initials of the builders and dates were often cut into lintel or cornerstones. Many of these carved stones may still be seen. The stones themselves retain their crude shape. The initials serve to preserve the spirit of the original owner of the home.

In Rhinebeck, gambrel roofs were used in the Kip-Beekman-Heermance House and for the Traphagen Tavern, once occupying a site on West Market Street. These roofs may not have been the original roof configurations since the accepted authorities insist that gambrel roofs were only introduced in the mid-eighteenth century. However, examples of early dated roofs of this type do exist in the Hudson Valley. The overhang of the front roof, sheltering a porch, is considered to be a typical Dutch feature. In Rhinebeck, it is found in the early period on only one house, the Steenberg Tavern on Route 9, south of the village. It features a long, gracefully flared roof, which was probably added when the house was enlarged.[5] An adaptation may be seen on the Feller House at the north end of the town.

Walls were thick and the windows were originally small, with as many as twelve over twelve panes. Miss Reynolds believed that windows were omitted partially to keep out the cold and partially for economy. She also discussed chimneys, which are found both in the center of buildings and in the gable ends. The fireplace was the center of activity, offering warmth and sociability, and was where the cooking was done. Beds were often located next to the chimney in the main living room and were curtained off or enclosed by cupboard doors.

Many of these homes retain extremely wide floorboards, which were fashioned from primeval trees. Virgin forests offered very tall trees with hefty girths. Often the second-story floorboards served as the ceiling for the first-floor rooms.

Fireplace openings were generous in size. Early construction featured a jambless fireplace. This meant that the fire was not enclosed by walls on the side or mantel on the front but was simply laid on the hearth. The smoke rose through an opening at the ceiling. Heat (and smoke) could then easily dissipate throughout the room. These fireplaces would have accommodated very large logs and burned constantly to keep the family warm and provide heat for cooking. An arch in the basement, giving the false impression of a basement fireplace, often supported a first-floor fireplace. In later renovations, fireplaces were enclosed with a mantel and often reduced in size. Eventually patent iron stoves, recognized for their utility, were installed instead of fireplaces or the fireplace was closed and a stove installed in front to utilize the chimney.

Outbuildings would have included barns, an outhouse, a smokehouse and a well. Most early wells featured a well sweep, offering a lever arrangement to raise a bucket filled with water. Later well houses were built utilizing a rope and pulley to raise the bucket. Several well houses, with shingled roofs and latticed upper portion, have survived and are in various states of repair.

Houses were generally set close to a path, and many of these paths eventually became town roads. The earliest known map of the whole of Rhinebeck, prepared in 1798 by Alexander Thompson, does not show all roads. In many cases, a line of houses indicates an area where a town road now exists.

Lists of path masters, given each year in the earliest town records, allow us to trace the development of roads in the town. The path master was appointed annually and was responsible for a certain road or portion of a road. It was his duty to organize the landowners along the road to maintain the road and give special attention to the fords or bridges. *Rhinebeck Road Records 1722–1857* by Arthur Kelly offers descriptions of the roads assigned to the path masters. By the end of the nineteenth century, the system became too cumbersome and a highway superintendent was elected with property taxes providing a budget and the ability to use hired labor.

KIPSBERGEN STONE HOUSES

Rhinebeck's first stone houses were located near the river. Five Dutchmen from Ulster County on the west shore of the Hudson River received the

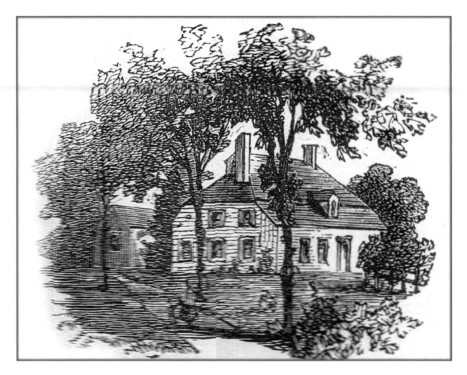

ARCHETYPE: 1700 Hendrick Kip House from 1866 etching.

Roosa & Company patent in 1688 for land on the east side of the river. The Kip family bought land at the north end of this patent so that their purchase would be included in the patent. The Kip land was located just north of present-day Rhinecliff and included a landing that had been previously used by the natives. Henry Beekman later referred to these Indians as the Sepascot Indians. The Indian trail, known as the Sepascot Trail, led east from the landing. It was the first land route established in this area and provided convenient passage to the east.

Rhinecliff Road, Kip-Beekman-Heermance House, Landmark District, 1700

Brothers Hendrick and Jacobus Kip were descendants of Hendrick and Tryntje Kip, who had come to America in 1637.[6] The Kip family preserved their original deed for land purchased from the Esopus Indians, dated July 28, 1686.[7]

The house built by Hendrick Kip on this land had a lintel stone with the inscription "Ao 1700 HK AK"—the initials of Hendrick and those of his wife, Anneke Jans Van Putten, along with the year 1700. The stone is

now displayed in the lobby of the Rhinebeck Post Office with photos of their portraits. In 1700, Henry was the captain of a militia company serving Ulster and Dutchess Counties.

The original house was square with a steep Dutch roof and a dormer window on the front. In 1724, the building was acquired by Colonel Henry Beekman (1688–1775) and was expanded with gambrel-roofed additions on the north to become the "mansion" of this period. He brought his second wife, the beautiful Gertrude Van Cortlandt, to live there. The house was conveniently located near the river and a dock that served the ferry to Kingston and sloops to New York City. It was an ideal site from which to oversee his property.

Henry Beekman's father, Judge Henry Beekman (1652–1716), had purchased land from the Indians surrounding the earlier Kip-Roosa patent. He obtained patents for his land in 1687 and 1703. The Beekman land covered the majority of the present town of Rhinebeck and part of the town of Red Hook. It included 21,766 acres, or thirty-four square miles. Henry maintained ownership of much of his patent, selling only occasional parcels but mainly employing a leasehold system, requiring annual rents. This practice was continued through generations of Beekman heirs.

Although he settled in Rhinebeck, Colonel Henry Beekman's lifestyle was not as restricted as that of the typical yeoman. In addition to his river home in Rhinebeck, he maintained lodging in New York City. There, he held the position of sheriff for five years. He was also one of two representatives from Dutchess County in the Provincial Assembly from 1724 to 1758.

His account books show that he maintained an active business, supplying goods imported from New York. The first settlers on his land were the Dutch and Huguenot families from Ulster County. About 1713, he leased property to a group of thirty-five German Palatine families who came to Rhinebeck at his invitation after the British 1710 "tar from pine trees" project at East Camp (Germantown in Columbia County) was disbanded.[8]

Leasehold land was not held in fee simple but required the "owner" to pay a yearly rent to the landlord. This was usually calculated in schepels of wheat per acre and often required payment of several hens and a day's labor (work for the landlord).

Henry collected annual rents from his leases, providing a comfortable income. His seat in the Provincial Assembly offered him great influence. The house was expanded with several additions and became the manor house for his patent.

After Henry's death at the beginning of the Revolution, Pierre Van Cortlandt occupied the house in 1778, probably as a refugee during the

Revolution. Colonel Harry Livingston inherited the property in 1786 and lived there until his death. He was a grandson of Henry Beekman II. Henry's grandson was eccentric and could be found plowing while dressed in long silk stockings and with silver buckles on his shoes. His daughter, Margaret, sold the property to Andrew Heermance. Eventually, it was transferred to the Suckley family, descendants of Henry Beekman. They were the owners of the property when it burned in 1910.[9]

In 1939, the 1700 building was used as a model for the Rhinebeck Post Office at the urging of Hyde Park neighbor and U.S. president Franklin D. Roosevelt.

In 1976, the ruins and property on which they stood were donated to the Rhinebeck Historical Society.

20 Long Dock Road, Jacob Kip House, Landmark District, pre-1708, additions 1820, 1880

In 1702, Jacobus Kip took one lot from the middle of the Kip patent and built on that land. A large stone in the front wall bears the date 1708.[10]

Jacob Kip's house is located closest to the landing and dock on the Hudson River where he reportedly operated a ferry. Evidence found in the walls and floor of the house indicate that it had a jambless fireplace. The original structure was probably expanded after only a few years. The site offered a good view of river activities. Jacob conducted his ferry business, bringing travelers to and from Kingston on the west shore. An article written by Mrs. Jacob H. Strong shows that this house was known as Century House. The house includes a stone with the initials "HK" over the porch, indicating that Hendrick Kip lived there at one time. A wooden addition has been constructed to the rear. When Jacob died in 1733, his land included about nine hundred acres, some of which had been purchased from Henry Beekman.[11]

6 Long Dock Road, Abraham Kip House, Landmark District, circa 1703

Jacob Kip's son, Abraham, is identified with the house that stands facing Long Dock Road (Sepascot Trail) as it leads east. The earliest portion of this house is on the west end and was built on rising ground with the front door facing the Hudson and the chimney on the east wall. Hendrick Kip's son, John, who later sold land to Jacobus and moved to Fishkill, was probably the original builder.

Abraham obtained a charter for a ferry in 1752, allowing Abraham Kip and Moses Contine (the owner of the charter on the west shore), exclusive

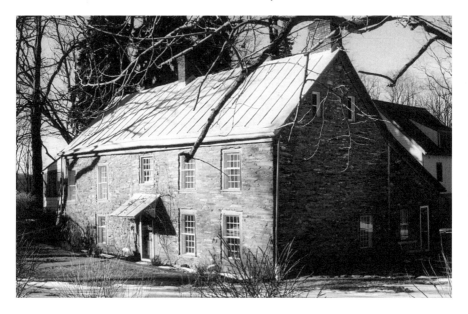

6 Long Dock Road, Abraham Kip House, circa 1703. *Courtesy Tom Daley.*

rights to ferry within a two-mile radius. The ferry was maintained by the Kips until at least 1785. It was traditionally described as a "periauger" of two cottonwood trees lashed together.[12]

The later section of the house, two stories high, was constructed on lower land to the east, placing the original chimney along a central hall. A construction joint is visible to the left of the front door.

The house was used as an inn, sheltering travelers on the river and those doing business at the dock. Its location on the early east–west trail must have drawn many travelers to it. The large east room with fireplace is filled with memories of the travelers who slept near the fire.

River Road, Pond Cottage, Clifton Point, Landmark District, circa 1724

Overlooking a pond with a spring, this stone dwelling is not visible from the highway. John Kip, son of patentee Jacob Kip, probably built his house soon after the purchase of the land in 1724.

Including his portion of the Kip patent, Jacob acquired over nine hundred acres and bequeathed land to each of his nine children. The homes of Abraham and John survive. Other houses built by sons of Jacob Kip have been razed. Isaac's home was built in 1730, near flat rock (corner of River

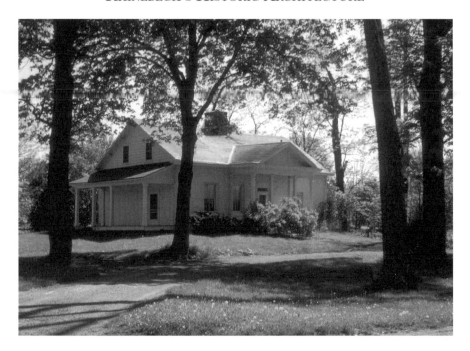

River Road, Pond Cottage, John Kip, circa 1724. *Courtesy Tom Daley.*

Road and Rhinecliff Road), and was taken down before 1898, and Roeloff's stone house was built near the river, north of Long Dock in 1735, on land later part of the Ankony estate.[13]

John Kip and his wife, Margriet Van Etten, had twelve children.[14] The small house must have overflowed with occupants!

In 1796, Joseph Teel, a Massachusetts Patriot who served in the Revolution, acquired the Pond Cottage and farm.[15] By 1867, the house was the property of Freeborn T. Garrettson, grandnephew of Reverend Freeborn Garrettson. The Greek Revival porch, giving the building a more formal appearance, was probably added about 1848, perhaps when the nephew's son, Freeborn Jr., was married.[16]

Sometime after 1896, the Astors acquired the Garrettson property for their Ferncliff estate. At present, the portion containing Pond Cottage, along with the Astor stone barn complex, is a separate property known as Clifton Point. The Kip House and Astor stone barns have recently been renovated and restored.

SEPASCOT TRAIL STONE HOUSES

The Sepascot Trail led east from the Hudson River landing to a spring near what is now the four corners at the Beekman Arms in Rhinebeck. The trail traditionally continued east along the Landsman Kill toward Lake Sepasco, where the natives originally had a village. This road became the Salisbury Turnpike and is now Route 308.

Most of the stone houses that fronted Rhinebeck's first road or trail have been demolished. One was located west of Bollenbecker Road, another stood across from White Schoolhouse Road and a third was located in Eighmyville. Early stone houses were later considered to be out of date and not worthy of preservation.

55 Wynkoop Lane, Traver House, Multi-R District, circa 1730

Built about 1730, the Traver House is located off the Sepascot Trail on Wynkoop Lane. The house is a two-story stone and frame farmhouse, built into a steep hillside, with two doors and windows below grade level. The roof is steeply pitched. Molded-brick end chimneys rise above the gable peaks of clapboard. The primary entrance is in the north gable end. Significant

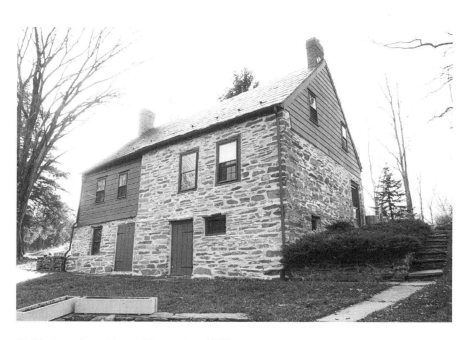

55 Wynkoop Lane, Traver House, circa 1730.

interior elements such as beams, floorboards, fireplace surrounds and doors remain largely intact. The oldest section is the one-room part to the north. It probably dates to the 1730–50 period. The hewn beams in the older section are massive and have slight chamfers.

The section to the south dates to about 1790. A kitchen addition and part of the rear wall were removed and a frame wing was added about 1959. It spans the width of the 1790 stone and frame block but does not detract from the front façade.

The October 26, 1929 edition of the *Rhinebeck Gazette* describes bins found in the top story or garret of the building. These were traditionally used to store grain out of the reach of pilfering Indians. However, there are more practical reasons that local grain was stored in the garret of a house. It was more secure from rodents than in the barn and would have been a dryer atmosphere, because even when heat was not required, a fire for cooking was always burning in the fireplace.

Anna Maria Hoffman, the widow of Nicholas Traver/Treber from Woellstein in Wurtemburg, Germany, was among the 1710 Palatine families. She married Joseph Reichert and came to Rhinebeck with her sons, Bastian and Peter Traver. This house is believed to have been the home of the elder son, Bastian Traver. The owner in 1984 reported the presence of the ghost of Alice, wife of a Traver descendant in the house.

202 Route 308, Jan Pier House, Multi-R District, circa 1761, additions 1774, 1881

The Jan Pier House is sited on the south side of the Sepascot Indian Trail. Jan Pier's house, with a stone inscribed "Jan Pier, 1774," fronts on this road. An earlier house built by his father, Tunis Pier, was located on the opposite side of the Landsman Kill and was probably used by the miller, since the stream was dammed to provide water power.

The section of Jan Pier's house facing Route 308 was built in 1761. An excavation into the hillside accommodated the present cellar and pantry with a staircase to the second-floor back hall. Two large rooms were on the second floor with a front and back hall between.

Later construction by Tunis Pier (a grandson of the first Tunis) occurred in 1768. A large room on the ground-floor level with the cellar provided a dining room, and another room on the second floor was used for a living room. The house had gable roofs with walls approximately two feet thick.

The miller Isaac Davis acquired the house about 1796.[17] At the end of the nineteenth century, Jacob Tremper was the owner. He had six sons and

two daughters. In 1881, he built an extension on the back for a kitchen with bedroom above. He also built a mansard roof over the house in the fashionable Second Empire style, providing a third floor with four medium-sized bedrooms and a large square hall. There was a separate large bedroom with a nursery extension. Two stairways led to the third floor, one in the back hall to reach the four bedrooms and one from the living room to the large bedroom. The complicated floor plan encouraged tales of creaking floors and furtive ghosts.[18]

Jacob Tremper was a meat dealer. The slaughterhouse in his barn included a large wheel used to elevate the carcasses. In 1907, Tremper sold his meat business, having completed forty-nine years as a butcher. He died in 1920, two weeks after his wife.[19]

Currently, the building is a one-and-a-half-story, five-bay rectangular structure with a symmetrical plan and Second Empire details. The ground-floor windows are two over two with plain sills and lintels, and the dormers, which are inserted into the slate-covered mansard roof, are paired one over one with round arch upper lights under triangular pediments. A simple boxed cornice with plain frieze extends around the perimeter of the building. The broad façade porch has massive square column supports and a bracketed cornice. The Second Empire elements (mansard roof, porch and windows)

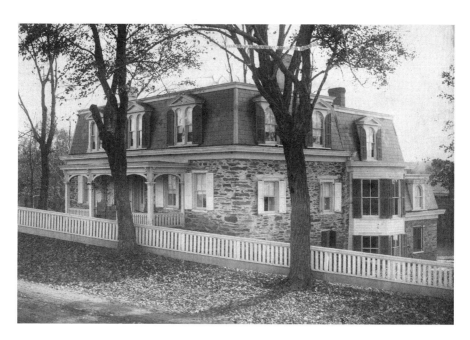

202 Route 308, Jan Pier House, circa 1761. *Courtesy Kay Verrilli.*

are sensitively incorporated into the original design, and therefore, the house illustrates a continuum of building styles. The polychrome slate mansard roof has recently been replaced with a careful reproduction of the original.

KING'S HIGHWAY STONE HOUSES

A series of stone houses was built on property fronting the King's Highway, later called the Albany Post Road, now Route 9. This was the second road established in Rhinebeck. In 1703, an act for the better laying out and regulating of a post road from King's Bridge to Albany was passed in the colonial legislature. At this time, the town was sparsely settled. The Hudson River offered the preferred means of transportation.

With the advent of the Post Road, properties along the road enjoyed transportation advantages not available to inland locations. Travel was mainly by foot. In time the trail was passable by horseback, and horses could carry two or three persons when a pillion was on the back of the saddle. Eventually, oxcart, one-horse dray, chaise, buggy and stagecoach began to ply the road. Regular stagecoach lines were established traveling between New York and Albany, and horses were changed at specific tavern stops along the route.[20] Many houses along the route became taverns, accommodating the thirsty and the tired.

97 Old Post Road, Stephen Fraleigh House, Landmark District, circa 1810, 1870

The Stephen Fraleigh House, north of the state police barracks, has a two-story clapboard addition that was added to a large stone house, built with two exposed walls. Henry Beekman and his two sisters gave a lease for Stephen's land in 1719. A lease for additional land in 1723 was found at the Staatsburgh House State Historic Site. It shows that Stephen was required to pay twelve schepels of wheat annually and two fat hens. Fraleigh is shown on the 1802 map prepared for Morgan Lewis, whose wife was a granddaughter of Henry Beekman. Rent records survive at the Staatsburgh State Historic Site.

Records of Domine Hartwick, a Lutheran minister, show that he conducted services at Staatsburg, probably near Stephen Fraleigh's house in a structure once used as a barn. A cemetery was located across the road from the house.[21]

Although located near the New York State police barracks, on foggy nights the cemetery site, now difficult to discern, is said to be haunted by the early settlers who were interred there.

66 Fox Hollow Road, Adam Ackert House, Landmark District, 1719

The Ackert House is west of the Post Road, along Fox Hollow Road, a route followed by farmers, bringing their wheat to the Wurtemburg mill on the Landsman Kill. The mill served the land owned by Morgan Lewis. In 1802, this was most of the land south of Rhinebeck Village and was known as the "Wurttemburg" Tract.

The stone house built by Adam Ackert contains a stone lintel on the east side marked "A.E. 1719." Adam was from Wiesbaden near Mainz in Germany and was one of the original 1710 Palatines. In early records, the surname Ackert is often written as "Eckert."

Adam was a farmer and had a total of eighteen children with two wives. Many of his descendants remained in Rhinebeck and on the west shore of the Hudson. Adam Ackert and the other Palatine families in Rhinebeck had a strong sense of community and were very industrious. The land they settled became very fruitful.

The house has been enlarged with a frame addition. It was known later as the Abraham Brown House or Willowdale. Herman Braun (Brown) came to Rhinebeck in 1735 and settled near this spot. He had three sons. John, one of the sons, acquired the Ackert House and enlarged it in 1763. His son Abraham gave his name to the house, probably because of his long tenure there. It remained in the Brown family for a period of over two hundred years. The two-story addition was made to the house in 1850.

43 Wheeler Road, Fredenburg House, Multi-R District, Landmark District, 1716

The house, listed on the National Register of Historic Places as the Fredenburg House, has a cornerstone dated 1716. It is named for a later owner, a member of a Dutch family alternately found as Van Fradenburg, Fredenburg or Vradenburg.

South of Rhinebeck Village and west of Route 9 lies a broad fertile plain. Henry Beekman called it the Bocke Bush (Beech Woods). According to a circa 1749 map, he divided this land into four farms. Names of leaseholders on the farms appear on the map and include Eighmy, Freer, Shefer and Radcliff. Two surviving stone houses overlook the plain.

The *Bocke Bos* map seems to indicate that Nicholas Emigh/Eighmy, who held a lease in 1719, was the original owner of this property. This may explain why it exhibits German characteristics. Nicholas was one of the original Palatine settlers of Rhinebeck, coming from Dannenfels in Nassau

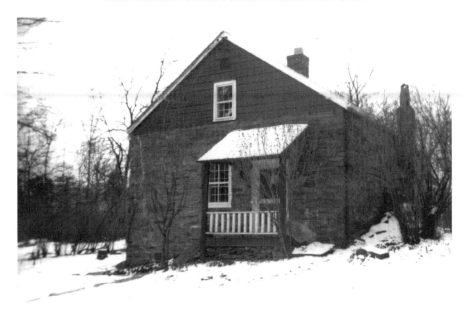

43 Wheeler Road, Fredenburg House, 1716.

with his family.[22] He left Rhinebeck by 1728 to settle in Beekman, Dutchess County, where larger farms were available.

Like other German vernacular houses of the period, the Fredenburg House has clapboard siding in the gable ends, its primary entrance is in the end rather than through a side wall and it utilizes a hillside site.

The building is one and a half stories with twelve-over-eight windows and an open porch with shed hood. An open stoop of later date is on the south elevation. Miss Reynolds identifies it as typical of the houses that dotted the King's Highway all along its course.[23] The garret level retains a domed section of the chimney that served as a meat-smoking chamber.

The house later became the property of the Fredenburg family. By the mid-nineteenth century it had been acquired by the Livingston family and was associated with the Grasmere estate. While this book was being prepared, the current owner placed a large frame addition on the north side of the house.

6125 Route 9, Steenberg Tavern, Multi-R District, Landmark District, circa 1750

South of Rhinebeck and on the west side of the road, the Steenberg Tavern overlooks the Bocke Bush and probably was part of the Freer farm. The

Colonial Stone Houses, 1700–1775

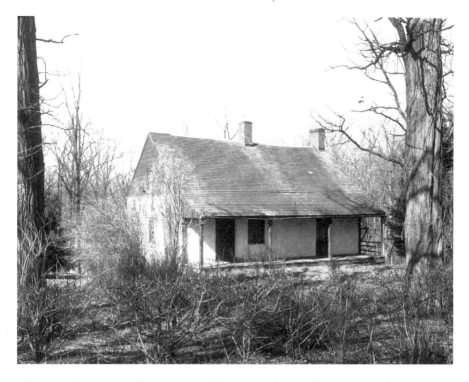

6125 Route 9, Steenberg Tavern, circa 1750. *Courtesy Dutchess County Historical Society.*

Bocke Bush map shows Joachim Radcliff (Jogham Radley) living on the property circa 1749. It is probable that he was the original builder of the house. Joachim was listed with two slaves in the 1755 census.

The house is identified as a tavern on the 1798 Alexander Thompson map of Rhinebeck. The Benjamin van Steenberg who lived there was probably Benjamin Jr., who first appeared on tax lists in June 1767. Benjamin continued appearing on the tax lists through 1778, when the published list ends.

This house is four bays wide and two bays deep. It is a rectangular stone building with a sweeping gable. The whole building is exposed one story on the east, or front façade, and a full two stories on the rear elevation. It was constructed in two stages and is now a two-room linear-plan dwelling. The second part was added late in the eighteenth century. The central chimney was originally the north end chimney of the 1750 building. A massive beam, closest to the chimney, shows evidence of charring directly above the hearth area, indicative of the presence of an original, jambless fireplace. As with the Fredenburg House, the Steenberg Tavern includes a smoking chamber

in the garret level of the chimney. The rear includes a shed dormer, seven bays wide, added in the twentieth century. There are two Dutch-style doors with some original hardware.

The building later became a dependency to the Livingston estate, Grasmere, and is now privately owned.

77 Mill Street, Benner House, Multi-R District, circa 1730

Close to the southern border of the village is John Benner's circa 1730 house, now on Mill Street, east of Route 9. The road was originally part of the Post Road. Apparently, the road was laid out to avoid bisecting a large, productive plain. Too often modern highway construction has cut through fertile fields, limiting their usefulness. More modern improvements to the road have cut through the plain, placing the house on Mill Street with Route 9 a stone's throw away.

This building is a one-and-a-half-story, two-bay rectangular stone structure with a gable roof. The gable wall of the house faces the street. The apex of the gable is sheathed in clapboard, said to be characteristic of German vernacular building. The uncoarsed, locally quarried stone walls are typical of construction during this period. Alterations have included

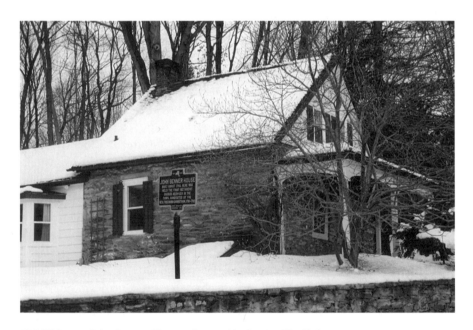

77 Mill Street, John Benner House, circa 1730. *Courtesy Tom Daley.*

a broad porch, extending across the asymmetrical façade, and windows inserted into the gable peak.

A stone retaining wall now separates the house from the street and may obscure the original level of the building.

There is no clear connection between John Benner in Rhinebeck and the early John Valentine Benner, a Palatine.[24] On a tax list, the Rhinebeck John Benner (Hans) is referred to as a newcomer in 1766. The house was used for the first Methodist meetings held in the town, conducted by the Reverend Freeborn Garrettson, 1791–92.[25] Later, in the nineteenth century, Dr. Walter Landon's writing school was located here. Civil War soldier Thomas O'Brien eventually occupied it.

163 Old Post Road, John Cox House, Multi-R District, remodeled circa 1842

North of the present Rhinebeck Village, on what is now called Old Post Road, is an early stone house that was occupied by John Cox Jr., a land surveyor and prolific draftsman. John Cox also served as Janet Livingston's estate manager. He was town supervisor and was elected to the state assembly in 1822.

The house has been well maintained. Once part of a large farm, it is now isolated on a small three-acre parcel of land. The original colonial structure was remodeled about 1842. It is a one-and-a-half-story, five-bay, stone structure with a gently sloping gable roof, surmounted by end chimneys along the ridge pole. The moderately projecting roof rises above a simple board frieze, which terminates in short returns at the gable ends. The symmetrical façade is characterized on the first floor by a massive central entrance door, recessed and flanked by two sets of engaged pilasters. A large brick wing extends to the rear.

The property was among others acquired by John Jacob Astor to add to his Ferncliff estate. Buildings were systematically moved or demolished. Of twenty-two buildings found in this area on the 1876 Gray's map, the Cox House is the only survivor.

WURTEMBURG STONE HOUSES

In addition to the Palatine families brought to Rhinebeck about 1713, Colonel Henry Beekman also arranged for the settlement of a number of families from the Wurtemburg area of Germany during the 1730s. Farms

were laid out for these families in the southeastern part of Rhinebeck. Most of the houses in this area are frame, but several stone houses may be found.

Settlers on the "Wurttemburg Tract" may be documented through Henry Beekman's rent lists. The Beekman Rent Books dated 1740–1812 have been located in the Edward Livingston Papers at Princeton. There are also account books that begin as early as 1719. Additional rent books (1799–1836) for the Wurtemburg Tract may be found in the Morgan Lewis Papers at Staatsburgh House. Records for the property from 1833 to 1917 are in the possession of the Dutchess County clerk's office.

The records show that some of the properties were held in leasehold as late as 1917, having descended from Morgan Lewis to Ruth, the wife of Ogden Mills. The land covered the southern portion of the town of Rhinebeck, east of the Landsman Kill. This major area of the Beekman patent was largely unsettled before the arrival of a second Palatine group. The Sipperley family who came to New York with the 1710 Palatine emigration were from Unterowisheim, Wurtemburg, and were among the earliest settlers in Rhinebeck. Perhaps they were instrumental in the settlement of the later Palatines who came between 1730 and 1740. Wurtemburg house sites in 1802 are shown on a map made for Morgan Lewis, who married Henry Beekman's granddaughter, Gertrude Livingston. Several stone houses survive on these lots where the Wurtemburgers settled far from the river. They must have been attracted by favorable terms and good farmland. They were a homogeneous group who held their first worship services in a building across from Stephen Fraleigh's house on the Post Road and thirty years later built a church farther to the east, in a location more central to their settlement. The neighborhood was given the name Wurtemburg. Many of the settlers and their descendants rest in the cemetery at the St. Paul's Lutheran Church in Wurtemburg.

12–14 Old Primrose Hill Road, Progue House, Multi-R District, 1763 datestone

Captain Matthias Progue/Brog was born 1709 in Neckarweihingen, Wurtemburg, Germany.[26] He died in 1795. His name is found on Rhinebeck precinct tax assessment lists 1740–41. Matthias became captain of a sloop for Henry Beekman and did business at Coenties Slip in New York City.[27] It is unclear for how long he was a ship captain.

According to the terms of a Beekman lease dated 1739, Matthias Progue paid rent on a 149-acre farm located on Primrose Hill Road. He and his wife, Christina Waldemier, had five sons and one daughter. Rent receipts, kept by

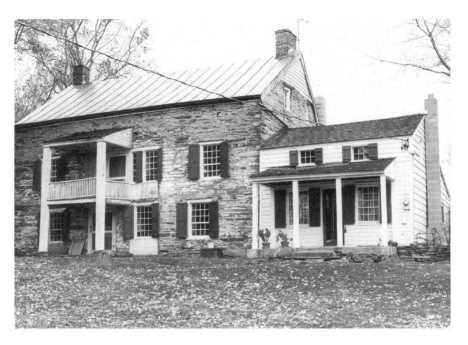

12 Old Primrose Hill Road, Matthias Progue House, 1763.

the family, were fashioned into a hand-sewn book dated 1747–85. In an eerie circumstance, Matthew's rent book came back to Rhinebeck from Michigan in 2001, where it had been discovered among some Methodist church records. It is now in the possession of the Museum of Rhinebeck History.

The initial annual rent for Progue was twelve schepels of merchantable wheat, two fat hens and one day's riding (work done for the landlord). Traditionally, the miller, employed by Beekman, signed the receipt. The first Beekman mill was located at the mouth of the Landsman Kill. Grain from Progue's was probably ground there, but a later mill located on the Landsman Kill near Crystal Lake may have been just as convenient. Later, when Morgan Lewis acquired the property, a mill was built on the Landsman Kill at the place called Buttermilk Falls. This mill was known as the Lewis or Wurtemburg Mill, and the Wurtemburg people were expected to have their grain ground there.

The 149-acre farm on Primrose Hill Road features a stone house dated 1763. A 1935 article by the DAR[28] says that a log house was originally located a short distance behind the present house. It was probably the family home during the first twenty years of its occupation of the land. The present house is built into a hillside with only its upper story exposed on the

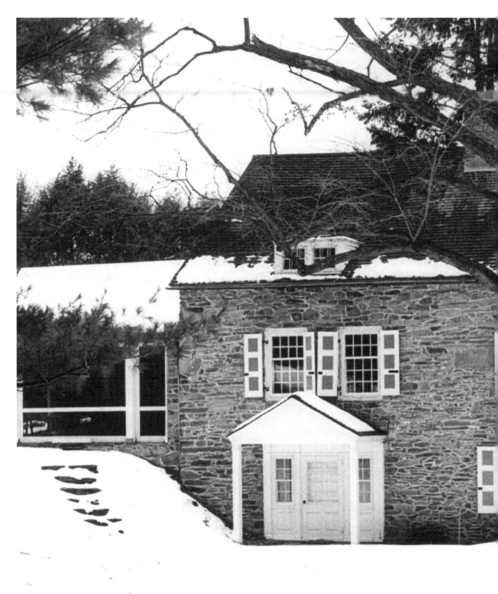

629 Ackert Hook Road, Strawberry Hill, circa 1762.

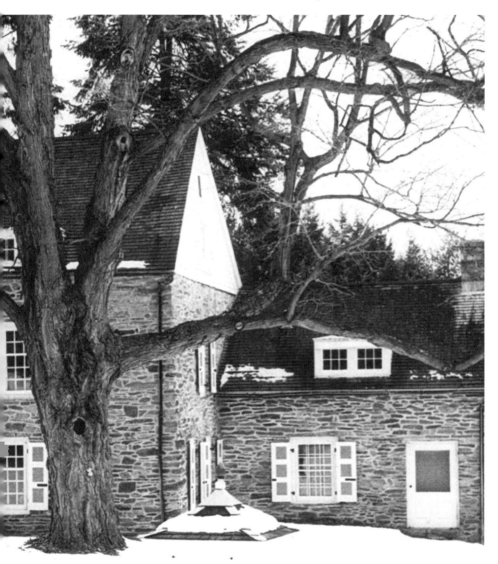

rear elevation. The front façade has a slightly asymmetrical four-bay-wide, center-hall composition. There are entrance doors on both the first- and second-floor levels. Both entrances contain Dutch-type double doors with original hardware. There is a simple two-story central porch with shed roof hood, supported by massive square posts. A simple railing extends around the second-floor landing. The unusually large stone portion of the house seems to have been built as a single unit.

Before 1875, Albert and Chester Traver were occupants. Ira H. Beach owned it during the twentieth century.

629–637 Ackert Hook Road, Strawberry Hill, Multi-R District, circa 1762

The George Crucius House, so called after its owner at the turn of the nineteenth century, is believed to have been built circa 1762. The property consisted of 188 acres in 1774, when George Adam Asher purchased it. George Adam Asher came to the United States in 1739 and may have lived on the property prior to the construction of the house and his purchase of the farm. As with all the property in the Wurtemburg Tract, the land continued to be owned by Henry Beekman; even the "sale" of 1774 did not relieve Mr. Asher from his annual rent obligations. The transaction actually resulted in a forever lease that allowed Asher use of the land in perpetuity.

This stone house is built into a hillside and is exposed one story on the west end. It has a two-room floor plan, found more often in German than in the three-room Dutch houses. The west half may have been the original one-room farmhouse. The kitchen was in the basement. A spring on the property would have been a desirable feature. Water was directed to the house for ease of access. The east end is a full two stories high. A story-and-a-half wing flanks the main block on the east.

A veranda or porch was added to the front of the house in 1870 but was removed in the middle of the twentieth century. Roof dormers are later additions, as is a screened porch to the west. The National Register listing calls this the most monumental stone farmhouse in the township and among the most significant in Northern Dutchess County.

A Dutch barn is included in the extensive building complex on the property.

703 River Road, Feller House, Landmark District, circa 1750

This stone house is built into the side of a hill and the basement floor has a central entry. There is a "Dutch" door on the first floor surmounted by

a five-pane transom. Three gabled dormers with eight-over-eight double-hung sash were added to the roof. There is a brick chimney in both gable ends. A five-bay porch has been added with a roof in the Dutch style. This eighteenth-century farmhouse was recently joined to a separate, much larger, building by means of an ell. The gables of the original include a frame apex. The Feller House features cut lintels and stone sills.

The Feller family in Rhinebeck is traced to Philip Feller, a Palatine from Guntersblum, south of Oppenheim. He married Catherina Elisabetha Rau (Rowe), with whom he had ten children. He was among the slaveholders in the 1755 census, holding Lou, a male, and Betty, a female. In 1760, he was paid ten pounds for two horses lost in the French and Indian War. His will, dated 1763, was probated in 1768.[29] The family resided in this house for many generations.

The property was part of the Delano's Steen Valetje estate from the 1870s. It still retains the estate gates and stone walls.

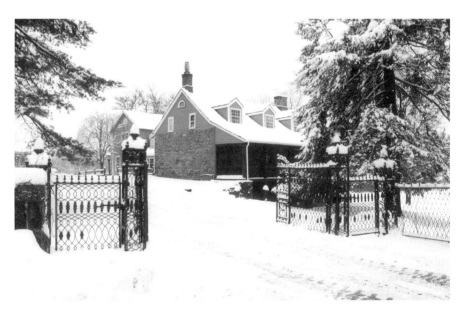

703 River Road, Feller House, circa 1750, with Steen Valatje estate gates. *Courtesy Tom Daley.*

CHAPTER 3

COLONIAL FRAME HOUSES,
1740–1810

S imilar to the stone houses, many frame houses also began as cellar
dwellings with the same large kitchen configuration found in the stone
houses and an exterior, grade-level door. However, instead of stone, the main
building materials above ground were wood. The frame was constructed
in the manner of a typical barn of the period. Large timbers with pegged
mortise and tenon joints were used with bents or sections in the construction
of the building.

John R. Stevens, in his book on Dutch vernacular architecture, suggests
that anchor beams supporting the hoods of jambless fireplaces were an inch
or two deeper than others beams. Occasionally, beams had a clear span of
as much as twenty feet.[30]

While these buildings often featured basement kitchens, an interesting
outbuilding also appeared. This was called a summer kitchen and must have
spared the main house from the heat of the cooking and preserving done
during the hot weather. When cold weather and snow threatened, cooking
could be resumed in the basement of the main house.

Helen W. Reynolds describes construction in Dutchess County prior to
1776 in her book *Dutchess County Doorways*. She quotes an advertisement
in the *New York Packet* of May 1783, proclaiming the sale of stock of John
Keating, Rhinebeck Flatts, including carpenter's hammers.

Well houses varied in size. Usually, a larger building was constructed when
the original water source was a spring. The springhouse or the well could
offer refrigeration for foodstuffs in the cool water. Similar to those for the
stone houses, the typical well house was simply a roof over the well and
usually supported a pulley system for raising the pails of water with a chock
to empty the pail. Latticework was often used to enclose the top half of the
well, while the lower portion offered a railing on which to balance the pail.

6196 U.S. Route 9, Palatine Farmstead, 1727, rebuilt 1830.

6196 U.S. Route 9, Neher-Elseffer House (Palatine Farmstead), NR, circa 1727, rebuilt 1830

The Neher-Elseffer property, known as the Palatine Farmstead, is being restored by the Palatine Farmstead Committee of the Quitman Resource Center for Preservation to tell the story of the Palatine settlement in Rhinebeck and the family who lived there.

It was first occupied by Frans Neher, a cordwainer, circa 1727. In 1762, he sold the property to Ludwig Elseffer, who, like Frans Neher, was a leather worker and saddle maker. The house remained in Ludwig's family until 2001, when it was acquired by the preservation organization. The house exhibits Federal-style characteristics arising from an 1830 remodeling and will be restored to that period. It features a Dutch barn and includes a well house near the main road.

Nearby, at the junction of Wey Road and Old Post Road, was the Kirchehoek, meaning church corner. Here the first church in Rhinebeck, a log building, was constructed about 1715. By 1749, a frame building replaced the log structure and was used by the German Reformed Congregation until about 1802. This was the focal point of "Old Rynbeck," where the first Palatine families settled and where Rhinebeck assumed the name. The Town of Rhinebeck maintains the cemetery at the location of the old church.

356 Wurtemburg Road, Pultz House, Multi-R District, circa 1750

The Pultz House, located on a 177½-acre parcel, was leased by Henry Beekman Jr. to Michel Pultz in 1769.[31] The house has been enlarged to become a three-part rectangular structure, parallel to the road. The original block—which is a five-bay, center-hall unit—may date from 1750. The center-hall rear door is a Dutch-type door with original hardware. The two-bay north wing may have been built as a separate structure about the same time, and the two joined together circa 1800.

The fieldstone foundation is fully exposed on the rear of the south wing and provided a convenient entrance to the kitchen located there.

Michel Pultz was active in the Lutheran church and gave some of the land to establish the church. The church is built at the edge of this parcel. By 1850, the house was owned by G. Pultz, having remained in the same family for a full century.

353 Old Post Road, Hayner House, 1772.

353 Old Post Road, J.W. Traver, Hayner (CJ's Pizza), 1772

When surveyed in 1980 for the National Register, this house was covered with asbestos siding. It is a two-story, five-bay house with boxed cornice and plain frieze. It has a Federal appearance with its delicate entablature, six-over-six windows and classical door surround.[32] Some of the original features may still be observed, although the building has been converted for commercial purpose and an entrance porch obscures part of the front façade.

The house has a stone marked 1772 in the basement.[33] It is shown on the 1798 map of Rhinebeck as property of M.R. Near. In 1867, the Beers Atlas map shows the owner as J.W. Traver, while on the 1876 map it was the property of Robert Hainer, with a blacksmith shop to the south. It remained in the Hainor/Hayner/Hainer family until about 1980.

77 Livingston Street, General Richard Montgomery House, Village District, 1773

The chapter house of the local Daughters of the American Revolution was built about 1773 and is now the earliest frame house in the village. General Richard Montgomery and his wife, Janet Livingston, occupied the house from 1773 until his service in the Revolutionary War as commander of the northern Continental forces. He was killed on December 31, 1775, in a disastrous assault on Quebec, becoming the first American general to be killed in the war.

When he died, he and his wife were in the process of building a new home of much larger proportions on land that Janet had inherited just south of the village of Rhinebeck. That house, known as Grasmere, is discussed in more detail in a later section.

In 1864, Montgomery's home was moved from Montgomery Street to the present location at 77 Livingston Street.

The General Montgomery House is five bays wide. The front door and windows date to the eighteenth century. There are end chimneys. The central one-story portico employing columns and a pediment trimmed with gingerbread work is not original.

77 Livingston Street, General Montgomery House, 1773. *Courtesy Tom Daley.*

161 East Market Street, Teil/Bourne House, Village District, circa 1780

This early house was probably constructed by Andrew Teal/Teil, whose name appears on the map surveyed by John Wigram in 1803 for Janet Livingston Montgomery. In 1803, Andrew Teil's property was more than two hundred acres in size and was outlined in red on the map, meaning that he had a permanent lease. Andrew's ancestor was Ananias Teil (1673–1733), a wheelwright who was one of the 1710 Palatines and came from Wiesbaden/Erbenheim.

The house is distinguished by its saltbox profile, small-paned windows and molded cornice with plain frieze. The dormer with a twenty-over-fifteen window would have been a later addition to the house. There is a basement door at ground level with the first story extending to the west. The original purpose of a small brick building located to the east of the main building is unclear; it may have been a springhouse or summer kitchen. Commodious barns, still standing, attest to use of the property as a working farm in the not-so-distant past.

Janet Montgomery's will, proven in 1829, shows that the property was still considered a part of her landholdings and that it was still in the possession of Andrew Teil.[34]

161 East Market Street, Teil House, circa 1780. *Courtesy Tom Daley.*

The house has been known as the Bourne House since James R. Bourne lived there for many years. He was an official in the Roosevelt administration. His wife was a cousin of John Foster Dulles, former secretary of state.

97 East Market Street, Peter Pultz House, Village District, 1795

One of the early Rhinebeck Village frame buildings is located at 97 East Market Street. This house was built about 1795, prior to the completion of the Salisbury Turnpike (East Market Street) as a through street. It was the home of Peter Pultz, who owned the Pultz Tavern located on the opposite side of the street during the turnpike days. A historical marker describing the tavern is located in front of 104 East Market Street.

The house has a molded cornice and wide clapboards, which have been covered with aluminum siding. It still boasts its decorative porch.

97 East Market Street, Peter Pultz House, circa 1795.

Colonial Frame Houses, 1740–1810

63070 Mill Street, Frost Law Office, Village District, 1800, circa 1840

This building was originally a residence. It is distinguished by a delicate molded cornice, half-round decoration, eight-over-twelve and twelve-over-twelve windows and features a paneled door and transom with lead tracery. In 1876, it was the home of Edwin Styles, the local jeweler, silversmith and clockmaker. In the twentieth century, it became the law office of Benson Frost and is now a real estate office.

34 East Market Street, Drury House, Village District, 1804

The law office of Herman Tietjen is an early one-and-a-half-story house. A large dormer window in the center front was probably added after the house was enlarged by an addition to the west. The original owner was probably John Drury, who married Hannah Wilson in 1804.

503 Wurtemburg Road, Cookingham House, 1807

This house is built of stone and timber. For generations, the stone was kept white by whitewashing. The whitewashing has now been removed, revealing the natural stone. A four-room addition was added to the building. The 1802 Lewis map shows the Wurtemburg Palatine Johannis Marquart living there on a 212-acre parcel. The records show that Marquart assigned property to Frederick Cookingham in 1807. The Lent family occupied the house after the Cookinghams.

Windows in the stone portion of the house are placed in three-foot-thick walls. The frame portion of the house extends to the north and includes a second floor.

GEORGIAN, FEDERAL HOUSES, 1790–1840

The Georgian style is identified with the reign of King George of England and reflected Renaissance ideals, which spread from England to America. The English publication of the works of Italian architect Andrea Palladio allowed his ideas to find expression in American architecture.

A number of Rhinebeck's historic houses may be said to conform to the Georgian style. In these houses, windows were regularly spaced and larger in size than in former colonial homes. Early houses of this period had three bays, while later examples commonly had five bays. This fenestration or grouping of windows on the face of a building offers an interesting way to study the evolution of the local architecture.

The Georgian houses built during this period were of two or three stories with a balanced symmetrical façade. It was a formal style with ordered placement of windows and a central door. Architectural historians find that early Georgian houses often had a rectangular transom over the front door. Sidelights on both sides of the door and quoins at the corners of the house were often employed. The center window on the second floor was often a flat-topped triple window or an elaborate Palladian window. Decorated cornices may be found at the eaves or over the windows.[35]

Following the death of Henry Beekman II in 1775, his daughter, Margaret Beekman Livingston, gave property from Henry's large holdings in Rhinebeck to her children, who were Henry's grandchildren. Many of the Livingston children settled on the land, building grand houses, most overlooking the river.

The Federal style of architecture was a later, more classic, form of Georgian, with graceful, delicate interiors. The most characteristic Federal motif is the porticoed doorway with an elliptical fanlight extending over narrow, flanking sidelights.

Federal is actually an adaptation of the ideas of Robert Adam (1728–1792). Interiors differed most noticeably from the earlier style. Mantels, cornices, door and window frames and ceilings were typically decorated with swags, urns, rosettes and oval patera (floral designs).

Kenneth Toole, writing in *Dutchess County Landmarks*, said, "It is often misleading to describe the architecture of a given building as 'pure' Georgian or 'pure' Federal, since there are no sharp lines of demarcation between the two styles. The majority of Hudson River estates built during this period embody characteristics of both."[36]

A period of economic depression had followed the Revolutionary War. Following this, the area entered a period of great prosperity, based mainly on agriculture. Large productive farms with access to the New York market produced influential farmers. Many substantial houses were built during this period.

In 1806, a group of forty-six prominent residents organized an agricultural society. The membership increased, and by 1809 the first Dutchess County Agricultural Fair was held.

This fair was then held annually and seems to have been mainly a cattle and livestock show, although by 1819 prizes listed included those for butter, cheese, Timothy seed and flannel. The 1823 list of premiums shows categories for animals, grain, roots, dairy, domestic manufactures and discretionary (miscellaneous).[37] The county fair was held annually, and in 1919 it was permanently moved to Rhinebeck. Rhinebeck citizens, including Philip Schuyler, Jacob Schryver and John Crooke, were involved with the agricultural society from its founding, and Rhinebeck people became even more active when the fair was situated in Rhinebeck.

29 Mill Road, Grasmere, Multi-R District, Landmark District, circa 1775, rebuilt 1828

Janet Livingston Montgomery, Henry Beekman's oldest granddaughter, established the Grasmere estate on the southern border of the village. She inherited much of Rhinebeck Village and land to the east. The house was originally begun by Richard and Janet Montgomery, but after Richard's death in Quebec, Janet lived there for only a few years before building Montgomery Place. Peter R. and Joanna Livingston, Janet's sister, acquired the house, but the original house was replaced after a devastating fire in 1828.[38] The two-story, five-bay, center-hall, Federal-style house with Georgian features may have retained the configuration of the original. During that same year, Peter Livingston was chairman of the New York Constitutional

29 Mill Road, Grasmere, circa 1775, rebuilt 1828. *Courtesy Tom Daley.*

Convention, which significantly democratized the governance of the state.[39] Unfortunately, Joanna died before the rebuilding was completed. Peter R. served several terms as state senator.

In 1861, changes to the house included a mansard roof. When Ernest Crosby bought the property, the west wing and a third story were added to the house, retaining the overall character of the Livingston-era mansion.[40] The interior features a forty-three-foot-long hallway, fourteen-foot-high ceilings and imported white marble fireplaces. A Palladian window placed at the rear of the building, brick quoins on the west wing and first-floor arched windows are interesting details.

A stone barn complex south of the main house and two stuccoed tenant houses on Mill Road were added in 1910.

In 1954, the property was sold to Louise Timpson, former Dutchess of Argyll. She described a ghost that she encountered on several occasions. From her description, Town Historian Dewitt Gurnell identified the ghost as Lewis Livingston, who had lived in the house until his death in 1886. Nearly twenty years earlier, Maunsell Crosby had reported just such an encounter with the ghost of L.L.

7015 Route 9, Quitman House, NR, 1798

The Quitman House, part of the National Register listing for the Evangelical Lutheran Church of St. Peter (Stone Church), was built as the parsonage and is authenticated by original documents of the St. Peter's Lutheran Church.[41] It was built in 1798 for the Reverend Frederick H. Quitman and his family, who had arrived in the United States from the island of Curacao a few years earlier. He resided in the house for about forty years, serving as pastor until 1828. The building, located north of the church on Route 9, is now the Quitman Resource Center for Preservation, providing preservation support and offering office space, and the Museum of Rhinebeck History.[42]

The front façade may be compared to the Wilcox House in New Jersey, documented by the Historic American Buildings Survey. The similarity of design would indicate that both houses followed the design from a plan book of the period. A Victorian porch on the Quitman House was removed during restoration. The house is a one-and-a-half-story structure with eyebrow windows and exhibits some Georgian characteristics, such as sidelights at the front door and cornices over the first-floor windows. The cellar is entered through a short flight of steps and does not show evidence of an early kitchen, although the current kitchen in a rear addition was clearly constructed later and began service as a kitchen at that time.

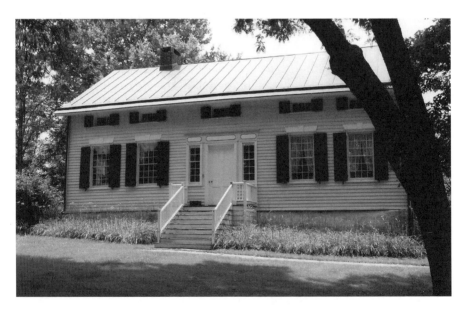

7015 Route 9, Quitman House, 1798. *Courtesy Tom Daley.*

Church records indicate that there was a separate stone kitchen. A Dutch door is located at the rear of the house.

Reverend Quitman's impressive three-hundred-pound body became feeble in his last years. A chain hanging over his bed helped him to be pulled up, and a sturdy sledge called a stone boat was necessary to deliver him to the church. His presence may be felt in the carefully maintained parsonage, where his desk and corner cabinet are displayed in the restored parlor.

524 Mill Road, Wildercliff, Landmark District, circa 1799

Wildercliff is located on land that was part of the first patent in Rhinebeck. The Van Wagenen land was on Lot 2 of the 1688 Kip-Roosa patent and was still occupied by the patentee Van Wagenen's family in 1799, when it was traded to the pioneer Methodist minister Freeborn Garrettson (1752–1827) and his wife, Beekman granddaughter Catherine Livingston (1752–1849). The Garrettsons offered fertile land to the east in exchange for the Van Wagenen river property, providing desirable views. The Garrettsons had built a Methodist church east of the Schuyler House on the Sepascot Trail. Soon after they exchanged the land with the Van Wagenen brothers, the church was moved closer to the population center in Rhinebeck.

Mrs. Garrettson recalled:

> *Our house being nearly finished, in October, 1799, we moved into it, and the first night in family prayer, while my blessed husband was dedicating it to the Lord, the place was filled with his presence, who in days of old filled the temple with his glory. Every heart rejoiced, and felt that God was with us of a truth. Such was our introduction into our new habitation.*[43]

Wildercliff is a Georgian/Federal-style house located on a bluff overlooking the Hudson River. The original structure with gambrel roof also has two gambrel-roofed dormers. There are four corbelled chimneys in the main block.

The house built by the Garrettsons was altered after 1830, acquiring French windows facing to the south and wings on each side of the main block. After the 1879 death of their daughter, Mary, Thomas Suckley purchased Wildercliff for $15,000.[44]

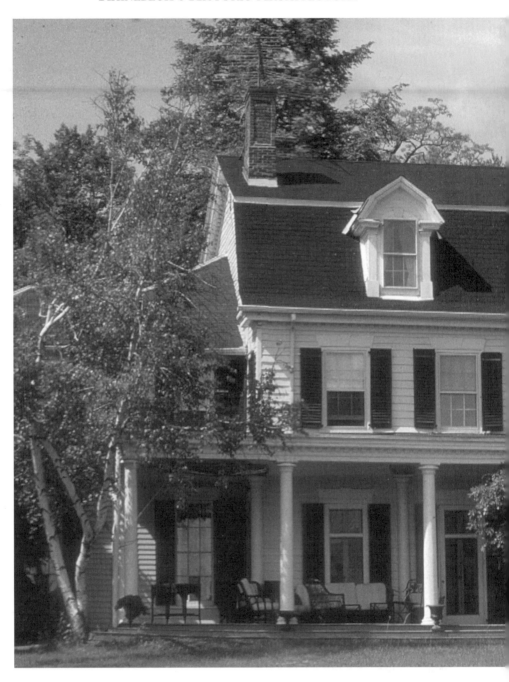

524 Mill Road, Wildercliff, circa 1799. *Courtesy Tom Daley.*

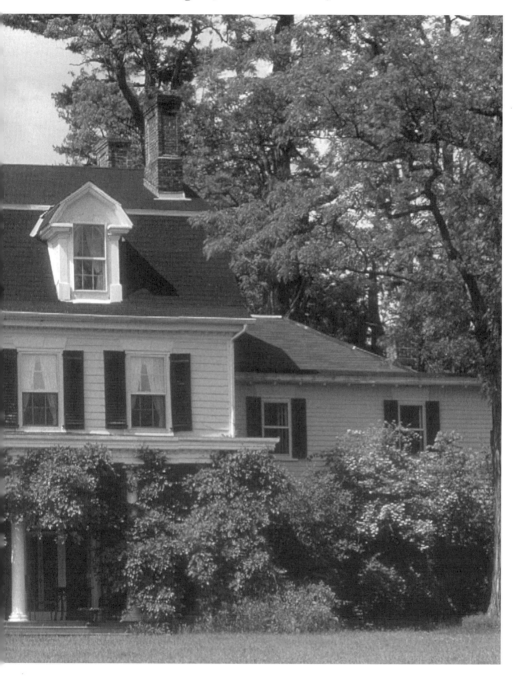

139 South Mill Road, Linwood, Landmark District, circa 1790

Thomas Tillotson established the estate, located on Lot 1 of the original 1688 patent, in 1790. His wife, Margaret Livingston, was one of the Beekman grandchildren. He was the surgeon general on Washington's staff during the Revolutionary War. Washington later visited this estate in Rhinebeck. Dr. Tillotson enlarged his estate to include the Beekman mills on the Landsman Kill south of Lot 1. After his death, the property was purchased by Federal Vanderburgh, then by John B. James and later by Augustus James. The author Henry James experienced life in the great houses of the Hudson Valley at this site.

The original five-bay brick building was torn down at the end of the nineteenth century, when Jacob Ruppert, a wealthy New York brewer, acquired the property. It passed from him to his nephew, Ruppert Schalk, owner of the New York Yankees, and it was later donated to the Sisters of St. Ursula, who in turn demolished his home to make room for the convent that now occupies the mansion site.

98 Miller Road, The Grove, Multi-R District, 1795

The Grove, now known as Schuyler House, was built in 1795 by Philip Jeremiah Schuyler (1768–1833), son of the Revolutionary War general Philip

98 Miller Road, The Grove, 1795. *Courtesy Tom Daley.*

John Schuyler. On February 29, 1794, Philip Jeremiah wrote to his brother in Albany asking for "plank and boards" to be sent down the river because, he said, it was impossible for him to get the lumber here in Rhinebeck. The list of lumber that he included was revised in a March 1 letter, requesting four pieces forty-six feet long, seven by ten inches, designed to be plates. This provides us the dimensions of the house as built.[45]

The five-bay, Federal-style mansion with central hall has been remodeled several times and now appears as a three-story, hip-roofed brick building with Neoclassical ornamentation. The one-, two- and three-story side and rear wings and additions contribute an overall asymmetry to the building. A one-story veranda (1890s) covers the raised basement and spans the south or front and west elevation of the main block.

Sarah Rutsen was born while the Rutsen family was living on the property in a stone house, situated not far from the 1739 Rutsen mill.[46] Sarah Rutsen's father, John, died at age twenty-eight, and in 1779, her mother, Phebe Carman Rutsen, married Robert Sands. For about fifteen years, Phebe and Robert lived in the Rutsen stone house at the mill with Sarah, her sister Catherine and the five Sands children. Catherine Rutsen later married George Suckley.

On May 31, 1788, Philip J. Schuyler married Sarah Rutsen, the daughter of John Rutsen and Phebe Carman and the great-granddaughter of Catherine Beekman Rutsen.

The original Henry Beekman patent was divided between Henry's three children—Catherine Beekman Rutsen, her sister Cornelia Livingston and her brother Henry II. In that manner, land in the eastern portion of Rhinebeck, along the present Route 308, descended to the Rutsen and Schuyler family. Despite the divisions made in the intervening generation, Sarah Rutsen Schuyler owned considerable property and collected sizeable quit rents.

Philip Schuyler and Robert Sands employed a miller and operated the mill for many years. Reminiscences of Eliza Bowne, Robert Sands's granddaughter, describe that they did a large business and also maintained a store near the mill.[47]

Family correspondence indicates that Schuyler was much involved in state and local politics.[48] Philip J. Schuyler served as major of the militia and as a member of the state assembly and the federal House of Representatives. Later family correspondence describes social activities including overnight visits to various river families with an occasional ball, suggesting that even in the winter social life continued in the mid-Hudson. About 1850, Mrs. Mary Regina Miller, Mr. Schuyler's niece, became the owner of The Grove. She

later bequeathed The Grove to her husband's nephew, George N. Miller Jr., MD. He was active in many community organizations and well known in the town.

Dr. Miller's elegant carriage house is located to the east. It was built in the 1890s and is discussed later in this book, under the heading of Stanford White.

377 Old Post Road, Moul's Tavern, circa 1790

Moul's Tavern is shown on the 1798 Alexander Thompson map of Rhinebeck. It was conveniently located for travelers and near the center of the original Rhinebeck settlement. Large houses often served as taverns in the neighborhood, providing a gathering place, selling hard liquor and offering a place to sleep overnight. Early records show that annual town meetings were held in the building. Jacob Moul/Maul was living in Rhinebeck when the 1740 census was taken.

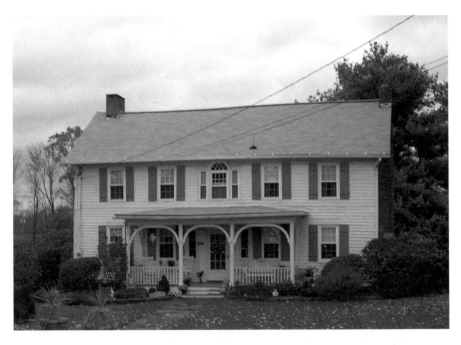

377 Old Post Road, Moul's Tavern, circa 1790.

The Palladian window in the façade of Moul's Tavern is noteworthy. The triple window with the center arch incorporated a design element much admired in this period. Somehow this feature found its way even to Palatine Rhinebeck. The Palladian style was admired for coherence, serenity and grandeur.[49]

4 Patten Road, Westfall House, 1719+, enlarged circa 1784

Situated on Patten Road, the site was probably established as a residence about 1719 when the Westfall family received a lease from Henry Beekman. The house as it now stands exhibits Georgian characteristics. Unfortunately, a datestone near the fireplace was removed because it was broken. The owner in 1970 did not know the date that was incised on the stone.

Quite possibly the lowest level of this house was the early residence of the Westfall family and was rebuilt or expanded after the Revolutionary War.

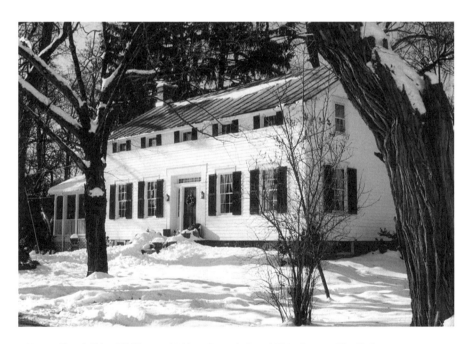

4 Patten Road, Westfall House, 1719, enlarged circa 1784. *Courtesy Tom Daley.*

531 Old Wurtemburg Road, Marquart House, Multi-R District, circa 1810

This large wooden structure with a five-bay symmetrical plan and twelve-over-twelve paned windows exhibits Federal styling. Six-over-four sidelights flank the central entrance. The house features large brick end chimneys and is constructed on a fieldstone foundation with an exposed wall at the southeast. It was built circa 1810 on property leased to Johannis Marquot (Marquart) in a deed dated May 1, 1791, from Honorable Chief Justice Morgan Lewis, Esq. The parcel contained 212 acres. It continued in the Marquart family until 1982. It was not released from an annual rent obligation until 1917, when a quit claim deed to the land was given from Ruth Mills, a descendant of Morgan Lewis.[50]

A 1930s rear wing was built on a stone foundation that exhibited signs of a nine-foot-wide stone Dutch hearth and beehive oven on the east end. A summer kitchen, well house, carriage house and wagon/machine shed were listed as contributing structures on the National Register. An H-frame Dutch barn and two smaller barns were located south of the house on the west side of Wurtemburg Road. Marquart/Marquot family history may be found in the March 22, 1884 issue of the *Rhinebeck Gazette*.

55 East Market Street, Schaad Bakery, Village District, circa 1795

Number 55 East Market Street is an early Federal, one-and-a-half-story house with twelve-over-twelve windows. It was built about 1795 and survived the 1864 fire that destroyed the Rhinebeck business district. Nicholas Drury, a barber, was the owner in 1867. Jacob Schaad lived there in 1876 and owned

55 East Market Street, Schaad Bakery, circa 1795. *Courtesy Tom Daley.*

the livery stable immediately to the west. The building retains twelve-over-twelve windows. A gable dormer has been added to the house, a common practice with many houses in Rhinebeck.

108 Montgomery Street, The Maples (Welcher House), J.H. Champlin House, Multi-R District, circa 1833

This building, characterized as Greek Revival style in the National Register listing, has an overlay of picturesque detailing from the 1860s. The floor plan is Georgian. The façade is a symmetrical arrangement of central entrance door flanked on either side by two French windows. A cornerstone indicates that it was erected in 1833, replacing or incorporating the farmhouse that was supposed to have occupied the property by 1817.

The five-bay house with French windows has dentil moldings in the cornice and narrow side windows flanking the front door. A nineteenth-century, delicately decorated porch adorns the front façade. Two one-story wings were removed in the twentieth century.

The spirit of Thomas Thompson (1797–1869) may be felt here. This was the boardinghouse where Thomas stayed when the kindness of a seamstress inspired him to remember Rhinebeck in his will. Her action has been of great benefit to the community. Thompson's bequest favored poor seamstresses

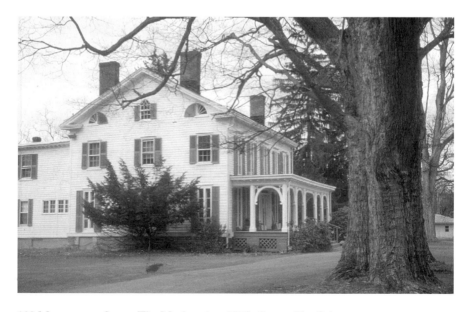

108 Montgomery Street, The Maples, circa 1833. *Courtesy Tom Daley.*

and healthcare but has been extended to benefit the community in many other ways.

At the turn of the century, John Jacob Astor maintained the house as a stopover for his friends motoring from New York to Albany.[51]

122 Violet Hill Road, J.E. Traver Farm, Multi-R District, circa 1850

Built before 1798, the farm was owned by J.E. Traver in 1850, when the house assumed its current exterior. In shape and form, the house exhibits Federal characteristics with a balanced, two-story, five-bay, center-hall composition. The rather elegant Federal-style entrance is surrounded by Doric-order pilasters supporting a broad lintel, reflecting the Greek Revival style. A picturesque cross gable with a round oculus was added to update the house during the Gothic Revival period.

Significant to the property is the large five-part barn complex, located southeast of the farmhouse.[52]

The farm was later owned by Philip Moore (b. 1781), a relative of J.E. Traver. Philip Moore and his wife, Anna Ring, are pictured in a tintype, now in the Museum of Rhinebeck History collection. They were dressed in black and looked very somber. She wore a white cap or kerchief tied under her chin. They were industrious, solid citizens of early Palatine stock.

79–85 Miller Road, Sands House, the Homestead, NR, built 1796

The Sands House was a well-regarded example of Federal architecture that burned in 1999. The family is discussed under the heading of The Grove, the site they occupied before building this house in 1796 on the opposite side of the Landsman Kill. It was a large wooden structure with a partially sunken basement, containing the original kitchen, laundry and possible slave quarters.

37–39 Red Tail Road, Barringer House, Multi-R District, Landmark District, circa 1812

Shown on the 1798 map of Rhinebeck, the house site is on a hill, overlooking a pond, north of Fox Hollow Road. Research shows that this property, owned by Morgan Lewis, was deeded/leased to John C. Barringer in 1806. The house was probably begun after this time and completed in 1812. It is one of the best examples of late Federal/early Greek Revival architecture in the area. Special note should be taken of the six-over-six windows, pedimented

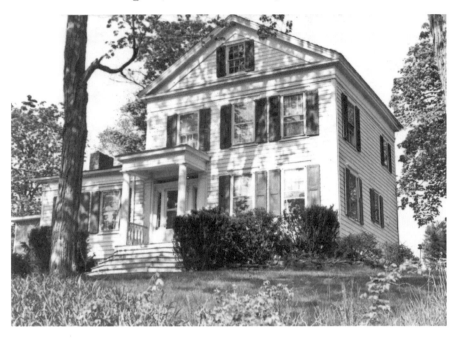

37 Red Tail Road, Barringer House, circa 1812.

gable, classical door surround and porch with a heavy frieze board. The cornice and frieze extend across the façade gable and form a broad triangular pediment with a central window.

The offset entrance portico has fluted columns, railing and a developed cornice leading to engaged pilasters, which flank sidelights. These surround a panel door and glazed transom.

The interior retains much of its period detailing with restrained Greek Revival influence, including mantelpieces, trim boards, staircase balusters and newell post. The original flooring remains in much of the house.

Outbuildings, including an early barn and corncrib, were pictured in photos taken circa 1984.[53]

GREEK REVIVAL HOUSES,
1830–1845

The movement to Neoclassicism in the United States signified a change in the economy, improving the life of many Americans from "subsistence" to "comfortable living." The new style embodied the most recent techniques of scientific planning and construction while reflecting classical elements from Greek archaeology.

Perhaps it is only natural that as classical literature and art became common elements of the education of those growing up after the Revolutionary War, their houses assumed the design of classical Greek architecture. Throughout the period, towns were growing and being newly built and this architectural style provided a quiet dignity that was much admired.[54]

Local architect Stephen Falatko believes that the Greek Revival influence came to the town along the Salisbury Turnpike, an east–west toll road running through the village of Rhinebeck and ending at the river. We find abundant evidence of this distinctive architecture in the schools, churches and houses along the turnpike.[55]

The Salisbury Turnpike was surveyed in 1802. With the opening of the turnpike, traffic increased through the town, carrying people and commerce through the village as they traveled between the Hudson River and Salisbury, Connecticut, in New England. Iron, animals and produce from the East traveled along the turnpike and were shipped downriver to markets in New York, while products from the city and coal from Pennsylvania traveled east. The toll road did not survive very long, but the route it followed continued to be an important east–west conduit, especially after the opening of the Erie Canal and the Delaware and Hudson Canal.

At this time, transitional framing combined the use of hand-hewn timbers with studs, which were produced at a sawmill. Brick nogging was a common unseen feature of many houses in the nineteenth century, serving to retard

flammability and deny space for rodents. Soft clay bricks were used with mortar to infill between timbers. The infill, most common at the first-floor level, served to provide insulation and minimize drafts. Floors were wide boards with no subflooring.

In the village, beautiful examples of the Greek Revival style grace the streets. Several houses along East Market Street preserve the best aspects of the style. Their occupants were professional and trade people who lived a genteel lifestyle. They were active in their church and leaders in the community.

Entrances were often on one side of the front façade, providing the building with a side hall. In the center hall variation, stairs were sometimes placed to the rear of the hall and a landing was featured part of the way up. These houses often have porticos with impressive columns to support them. The style usually exhibits corner details such as quoins, affecting stone construction or corner pilasters that imply built-in columns.

ASHER BENJAMIN (1773–1845)
Asher Benjamin lived and worked much of his life in Deerfield, Massachusetts. He was the first American architect to produce stylebooks, which were widely circulated. His stylebooks cover a long period, beginning in 1797 when Federal architecture was still in vogue. His book, *The Practical House Carpenter*, published in 1830, introduced classical Greek Revival architecture. Stylebooks offered advice, house plans and drawings of many detailed elements. Coincidentally, he died in 1845, about the time that the Greek Revival style faded from prominence.

5–29 River Road, Ankony, Landmark District, circa 1830

About 1830, Henry J. Kip, a distant, wealthy relative of the original Kipsbergen settlers, came from New York and built Ankony, a mansion in the Greek Revival style. Not far north of the old Kipsbergen stone houses and sited to overlook the Hudson, it was an imposing building. Rhinebeck craftsmen probably learned about the building style as Ankony took form, and many more lovely homes in this style soon graced the village and surrounding countryside. In the twentieth century, it was the home of State Senator Allan A. Ryan Jr. He established Ankony Angus in 1935. Ryan was chairman of Royal Typewriter Company, the company that his grandfather, Thomas Fortune Ryan, had founded in 1904. He established the Ankony Angus herd, which became famous throughout the United States. In 1966, an auction was held and the herd was moved from Rhinebeck to South Dakota.

The house was demolished in 1977.

Greek Revival Houses, 1830–1845

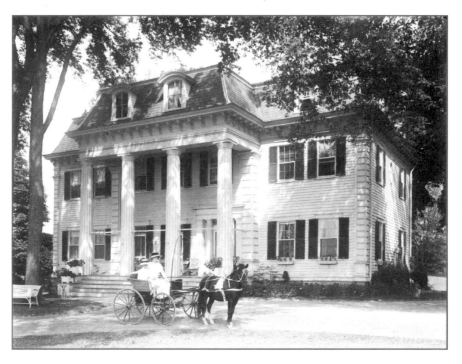

ARCHETYPE: 29 River Road, Ankony, circa 1830. *Courtesy of Rhinebeck Historical Society.*

The outbuildings include a one-story, Second Empire–style, frame stable residence with mansard roof and dormers. The main barn is crowned by a cupola and is surmounted by a polychromatic, slate shingle roof with decoratively sawn rafter ends.

RICHARD UPJOHN (1802–1878)
Upjohn was born at Shaftesbury in England, where he was originally in the business of cabinetmaking. He immigrated to Boston in 1829 and began an architecture firm in 1834. He became most famous for his Gothic churches, including Trinity Church in New York. He was also the first president of the American Institute of Architects. In 1842, he refurbished the original Ellerslie Mansion for William Kelly.

10–56 Holy Cross Way, Ellerslie, Landmark District, circa 1814

The first Ellerslie mansion, reputedly designed by Benjamin Latrobe, was built in 1814 for Maturin Livingston, whose wife, Margaret Lewis, was a

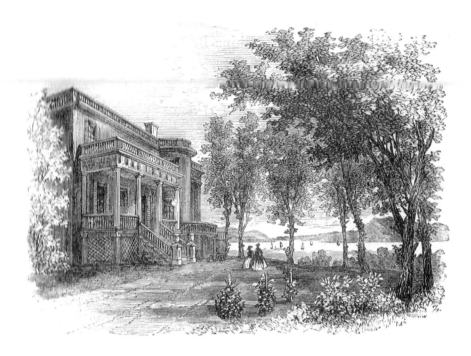

10 Holy Cross Way, Ellerslie, circa 1814, from 1866 etching.

descendant of the great landowner Henry Beekman. The house was closely connected to the original mansion at Staatsburgh House, owned by Mrs. Livingston's father. After only two years, Ellerslie was sold and the Livingstons took up permanent residence in Staatsburg.

A financier, William Kelly (1807–1872), bought the estate before 1841 and engaged in farming. Locally, he was the first president of the Starr Library from 1862 until his death. He was president of the state agricultural society in 1854, one of the founders of the state agricultural college at Ovid, New York, and president of its board of trustees. He was also president of the board of trustees of Vassar College from its founding until his death. He was a state senator in 1855–56 and the unsuccessful Democratic candidate for governor of New York in 1860. Kelly acquired land surrounding the estate until his holdings totaled nearly eight hundred acres. His widow maintained the property until her death in 1886. The *Rhinebeck Gazette* contains a glowing description of the estate grounds, lake and bridge, given by a visitor, Mr. V. Burgevine, in 1881. An 1866 book written and illustrated by Benjamin Lossing provides an etching of the first Ellerslie house. There were obviously fine views of the Hudson River from the verandas and many classical elements in the façade.[56]

Greek Revival Houses, 1830–1845

99 Salisbury Turnpike, Emighyville School (District 9), circa 1830

Four miles east of the village, on the Salisbury Turnpike, the District 9 schoolhouse at the hamlet of Eighmyville exhibits Greek Revival styling with its bell tower and corner trim. Though a wing has been added to the building, many of the classical elements may still be observed. The property reverted to the Suckley family and was the home of Daisy's sister, Katharine, for many years. The Stone Church Schoolhouse is the only other one-room school in Rhinebeck exhibiting the classical influence. It is also the only unaltered one-room school building in the town and is part of the Stone Church complex on the National Register.

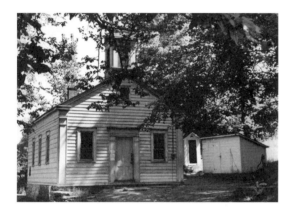

99 Salisbury Turnpike, Emighyville School, circa 1830.

178 East Market Street, Lawnknoll (Hermanella Island), Village District, circa 1840

Entering the village from the east, the Gilbert Traver House on the left at 178 East Market Street displays an unusual single-story portico of coupled Ionic columns. It is a substantial house with molded cornice and a paneled door with sidelights. Herman Kilmer and Ella Stickle Kilmer combined their names to provide the name for their tourist boarding home in the twentieth century.

83 East Market Street, Methodist Episcopal Church, Village District, 1822, 1843

The Methodists built a church at 83 East Market in 1822. A portico and bell tower were added in 1843, creating a classical façade. The *Rhinebeck Gazette* reported the burning of the Methodist church on February 18, 1899, and

the building was replaced by the current structure, which reflects turn-of-the-twentieth-century style.

Susan Bogert Warner began her writing career in 1849. (She wrote under the name of Elizabeth Wetherell.) Susan and her younger sister, Anna, visited Rhinebeck on several occasions, staying with the Schuyler family at The Grove and, later, near Mary Garrettson at Wilderstein. Susan's book *She Did What She Could* has the story set in Rhinebeck, but in the book, the town is called Shady Walk.[57] She describes Rhinebeck's bluestone sidewalks and a sermon at the Methodist church in the village.

Even at this early date, Rhinebeck must have presented a genteel atmosphere on East Market Street with the lovely Greek Revival buildings set off by large lots.

Perhaps you will see Susan's ghost, walking delicately along the bluestone sidewalk of East Market Street, passing these buildings on her way to Sunday service.

31 Livingston Street, Third Lutheran Church, Village District, circa 1842

Third Lutheran Church at 31 Livingston Street is reached from the former Turnpike route by driving north on Center Street. This building was constructed in 1842, possibly by Stephen McCarty. It was badly burned in 1909 but was reconstructed, preserving its Greek Revival style. It is noted for its rectangular

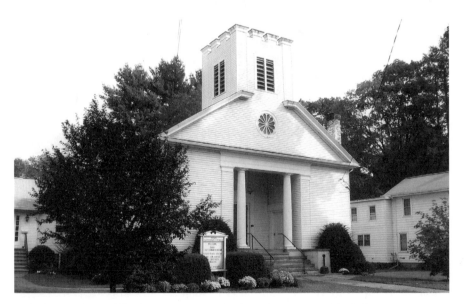

31 Livingston Street, Third Lutheran Church, circa 1842. *Courtesy Tom Daley.*

plan, centrally placed spire, recessed entrance and the classical columns, which were replaced in 1997. (The original, simple Greek Doric columns without bases were replaced with a more slender Roman Doric style with bases.)

STEPHEN McCARTY (1783–1870)

Stephen McCarty became one of Rhinebeck's most significant builder/architects. His work, found in many Rhinebeck homes and churches, has left a significant legacy. Stephen is first mentioned as a joiner and sash maker during construction of the Rhinebeck Reformed Church in 1807–8.

His father, Daniel McCarty (d. April 1, 1844, at ninety-one years), first came to Rhinebeck to work as a miller for the Schuylers, three miles east of the village.[58] In later years, he ran the lower gristmill for Beekman and lived in the old stone house by the mill.[59] Daniel and his wife, Elizabeth (d. January 26, 1841, at eighty-six years), are buried at the Rhinebeck Association Cemetery. They lived long and productive lives.

Stephen and his wife, Nancy (1787–1864), are also buried at the Rhinebeck Association Cemetery. An inventory at his death shows that his home was comfortably furnished. Their daughter, Julia, married William S. Cramer, captain of the Hudson River barge *Milan*, while their son, James, was an attorney.

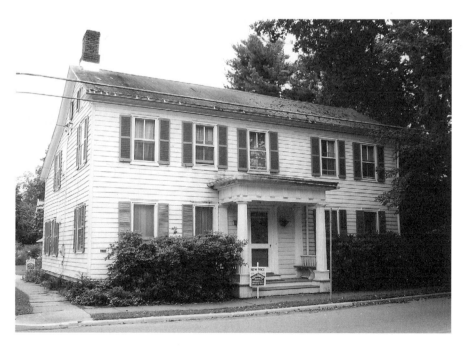

110 East Market Street, Stephen McCarty House, circa 1810. *Courtesy Tom Daley.*

110 East Market Street, Village District, circa 1810

Stephen McCarty lived in a Federal-style house at 110 East Market Street. It was built circa 1010, and a note in the DAR collection says that the building was an old tavern when purchased by Mr. McCarty. It was soon enhanced with a fine Greek Revival porch, evidence of his handiwork. It has Doric-order columns and a classical door surround with pilasters and transom with leaded tracery. The house originally was three bays wide. Stephen probably added the additional two bays to the west.

75 East Market Street, Village District, circa 1841

The house Stephen McCarty built at 75 East Market Street in Rhinebeck Village is admired for its style and craftsmanship. It was built about 1841, when the property was transferred to Stephen's brother, John McCarty.

The two-and-a-half-story, frame, clapboard dwelling has three bays on the front façade. The main entrance is at the left on the main façade, slightly recessed with sidelights and a transom. Corners of the front façade are finished with wide, flat, two-story pilasters, supporting an architrave and frieze that contains three oblong windows.

It is considered the most academically correct Greek Revival house in Rhinebeck.

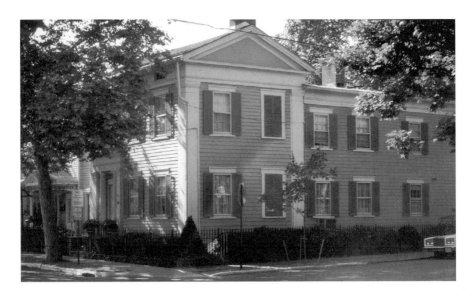

75 East Market Street, John McCarty House, circa 1841. *Courtesy Tom Daley.*

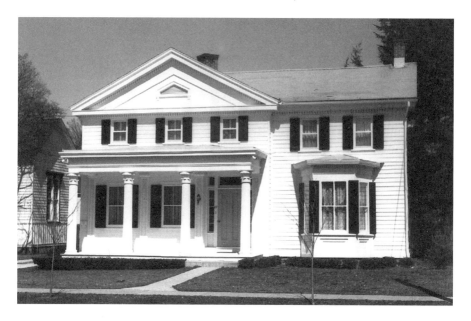

87 East Market Street, Hill House, circa 1845. *Courtesy Tom Daley.*

87 East Market Street, Hill House, Village District, circa 1845

Stephen McCarty is also thought to be responsible for 87 East Market Street, built circa 1845. This house features a large pediment and a molded cornice with dentils, plain frieze and pentagonal aperture. The porch with its proper classical entablature has Corinthian columns and articulated pilasters. The paneled entrance door has characteristically narrow sidelights and a transom.

It was the home of Edwin Hill, the third president of the First National Bank of Rhinebeck. In the twentieth century, it was the home of prominent jeweler Chester Haen.

122 East Market Street, Reverend Bell School, Village District, circa 1840

This temple front building was constructed about 1840. It is a two-story building and was built for Reverend Samuel Bell, who used it for a classical school that eventually moved to the Methodist church property and became the Rhinebeck Academy. It has been confused with the home and school of Robert Scott, which was actually on South Street. Reverend Scott was founder of the Baptist church in Rhinebeck.

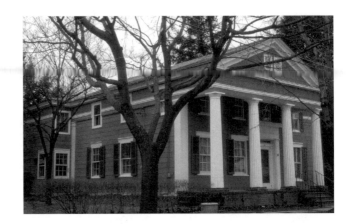

122 East Market
Street, Reverend Bell
School, circa 1840.
Courtesy Tom Daley.

Unfortunately, the building has been covered with asbestos shingles, which obscures some of the beautiful detailing. It is somewhat unusual that the second-story windows on the side façade protrude into the entablature.

51 South Street, Livery-Frazer House, Village District, circa 1840

Simple houses exhibiting Greek Revival characteristics include this house at the corner of South and Parsonage Streets. It is a two-story, three-bay plan, featuring a plain board entablature below a cornice with returns. The Parsonage Street entrance door retains its late Greek Revival surround. The house has been restored and is a remarkable improvement when compared to the 1979 National Register photo, showing it covered with asbestos shingles.

120 Old Post Road, Meadowsweep, Corke House, Landmark District, circa 1830

This house seems to predate Henry Corke, who came into ownership April 28, 1863, receiving the property from Andrew O'Dell and others in an estate sale.[60] The façade of the main house faces west toward the Hudson River. It is a two-story, five-bay structure with a plain boxed cornice and six-over-six stained-glass casement windows, featuring a deep front porch with Doric columns and balustrade above. It may have been built as early as 1830. There is a large stone chimney on the south and a wing to the north. Though aluminum siding and metal columns now detract from the building, the original design intent is retained. Many period elements remain visible. The deep Doric-columned porch is especially distinctive.

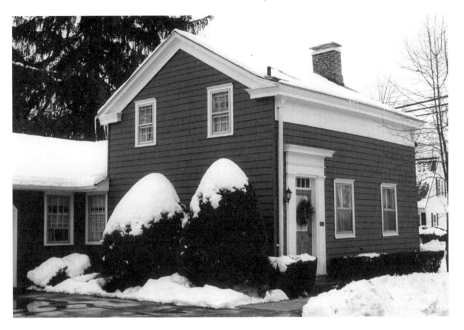

51 South Street, Livery-Frazer House, circa 1840. *Courtesy Tom Daley.*

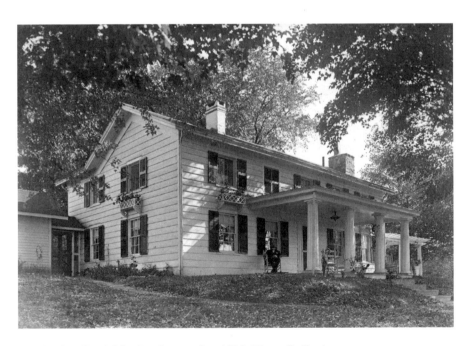

120 Old Post Road, Meadow Sweep, circa 1830. *Vintage Shaffer photo.*

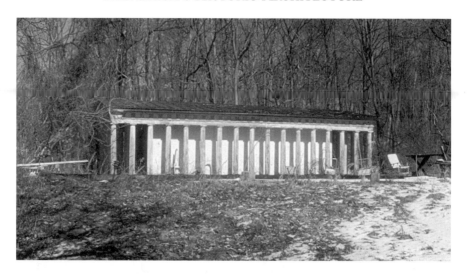

Old Post Road, Greek Temple, circa 1923. *Courtesy Tom Daley.*

The outbuildings of this residence include a windmill and a library designed to emulate the Parthenon. This library was built circa 1923, by local contractor Irving Staley for New York attorney John Gardner as a law library.[61] It was later used as a studio.[62] It is a one-story wooden building in the Doric order with full entablature, fluted columns and large central block. It has French doors on the north and a paneled door on the east. In its deteriorated condition, it looks particularly ghostly. John Gardner is probably turning in his grave, fretting about the future of his beautiful building.

Gardner also imported a four-story, shingled windmill. It has a gambrel roof, paneled door, six-over-six windows and long windmill blades. It is reported to have been transported from Holland and is described as a unique nineteenth-century structure in the Rhinebeck area.[63]

Details of Reformed Church, Wurtemburg Church and Stone Church

When the interiors of the Reformed church and the Wurtemburg church were remodeled to provide extra seating using a balcony, Stephen McCarty is said to have been the designer and builder. The resulting interiors have a classic elegance with their fluted pillars and finely decorated balcony fronts.

McCarty was also the builder of the steeples on the Reformed, Wurtemburg and Stone churches—their similarity may be easily noted. Perhaps the steeple on Independence Hall was his influence.

Greek Revival Houses, 1830–1845

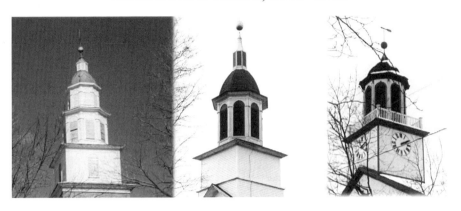

Left to right: St. Peter's (Stone Church), St. Paul's Wurtemburg, Reformed Church Steeples. *Courtesy Tom Daley.*

Route 9 North, Stone Church/St. Peter's Evangelical Lutheran Church, NR added 1975, 1786

The Stone Church, replacing a 1730 log church, was originally built in 1786 with the entrance facing the Post Road, and it was remodeled in 1824 when a bell tower and new entrance were added.[64] The octagonal shape of the tower is similar to that on the other two churches. The church served the St. Peter's Evangelical Lutheran congregation.

52 Wurtemburg Road, St. Paul's Lutheran Church, Wurtemburg, Multi-R District, 1802, 1832, 1861

Replacing a 1760 frame building, St. Paul's was built in 1802 in a Federal style, and the church incorporates the traditional meetinghouse design with two front doors. It was remodeled in the Romanesque style in 1832 and expanded with a tower and an octagonal steeple. The Classical balcony and features surrounding the chancel were constructed by Stephen McCarty. Remodeling in 1861 provided a basement under the building. The front façade features round arched front windows, doors and decorated cornices. It was the third building constructed by the St. Paul's Lutheran congregation, which was founded by the second wave of Palatine German emigrants to settle in Rhinebeck.

Reformed Church 1808, interior detail, circa 1832. *Courtesy Tom Daley.*

6368 Mill Street, Rhinebeck Reformed Church, Village District, 1808, 1832

Built in 1808 to replace a 1733 church, the Rhinebeck Dutch Reformed Church was constructed with Romanesque, round arched windows and doors in front and gothic windows on the sides. The adjacent front and side walls are made of brick, while the rear and east side walls are made of stone. Legend says that wealthy members of the congregation provided the brick walls while less well-to-do members brought fieldstone from their farms for use in the other walls.

Revolutionary War soldiers repose at the adjoining cemetery while Henry Beekman himself is said to be buried under the church.

6439 Montgomery Street, Village District, circa 1830

An early house that exhibits Greek Revival influence is the circa 1830 house at the corner of West Chestnut and Montgomery Streets. It has a classical door surround, five-sided bracketed-style wings and octagonal porch columns.

6406 Montgomery Street, Law Office, circa 1840. *Courtesy Tom Daley.*

6406 Montgomery Street, Law Office, Village District, circa 1840

The Law Office, originally 13 Montgomery Street, was built about 1840. The building was probably constructed for one of the Livingstons practicing law in Rhinebeck at that time and was used by John Armstrong Jr. The National Register application mentions Ambrose Wager, who occupied the office, but his law office was located on East Market Street until after the 1864 fire there.

The building was a one-room Greek Revival–style structure with temple front and flush board siding. Often attributed to Olin Dows, the muralist for the post office, murals hanging above the door in the twentieth century were commissioned by Harry Hill and painted by a Tivoli artist, von Thum (first name is unknown). They are now in storage.

The building became the Women's Exchange under the guidance of Laura Delano and has recently been used as a retail store.

57 Cedar Heights Road, Van Vradenburg Farmhouse, Multi-R District, circa 1830

A Greek Revival–style farmhouse is identified on the National Register as the Van Vradenburg House. It is a one-and-a-half-story, frame, rectangular structure with a low-pitched gable roof. The five-bay façade of the main

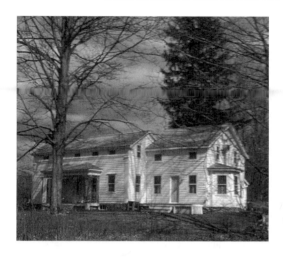

57 Cedar Heights Road, Van Vradenburg Farmhouse, circa 1830. *Courtesy Tom Daley.*

section is surmounted by a wide frieze board, pierced with eyebrow windows. A series of late nineteenth-century and early twentieth-century wings are clustered about the main section of the house.[65]

The house was owned by Van Vradenburg in 1844 according to deeds. In 1826, the farm had been leased to William Mink by Rutsen Suckley, a Beekman descendant.

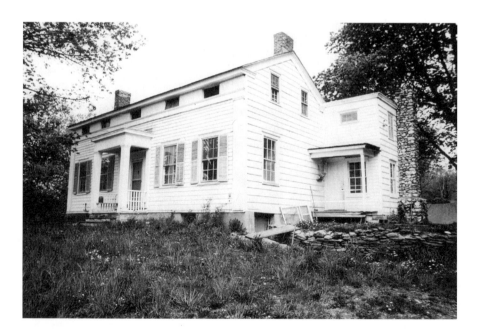

317 Enterprise Road, Williams Farmhouse, circa 1835.

Greek Revival Houses, 1830–1845

317 Enterprise Road, Williams Farmhouse, Multi-R District, circa 1835

A similarly styled, Greek Revival farmhouse is found isolated on Enterprise Road near the town of Milan. It is a one-and-a-half-story, gable-roofed form with eyebrow windows near the roofline. The front (south) façade features a trabeated, Greek Revival–style entrance with a slightly recessed, paneled door flanked by broad, fluted pilasters and half sidelights. A full one-story, flat-roofed porch supported by square, Doric-order columns shelters the entrance. Inside, door frames are embellished with molded surrounds and a shouldered architrave. Mantelpieces in the front parlors are original.[66]

Author Talbot Hamlin, in his book *Greek Revival Architecture in America*, wonders why the Greek Revival architectural style fell out of fashion. He believes that when the architecture was criticized for correctness, vitality died and with it the architectural style. The country was ready to move on to other ideas. People began to feel that they did not wish to be confined to the Greek style but would look to other styles for inspiration.[67]

CHAPTER 6

GOTHIC REVIVAL HOUSES, 1842–1870

New milling techniques contributed to a change in house styles. Balloon framing became possible when sawmills could turn out standardized lumber. The timbers were no longer hand hewn and smaller dimension studs could be used. These studs were two stories high; consequently, the ceilings in these buildings were often much higher than in earlier construction. The result was a house with a larger, grander feel and one constructed much more rapidly than post-and-beam houses. The use of balloon framing and steam-powered scroll saws made possible the steep gables and elaborate trim that became known as Carpenter Gothic.

ANDREW JACKSON DOWNING

After 1830, there was growing interest in the picturesque, especially under the influence of an arbiter of taste, landscape designer Andrew Jackson Downing (1815–1852), who worked in the Rhinebeck area. His landscape ideas were employed by Janet Montgomery at Montgomery Place, which he greatly admired. Montgomery Place is actually in Red Hook, but Janet had been living at Grasmere in Rhinebeck during the construction of Montgomery Place.[68] In a book published in 1859, Downing wrote, "There is no part of the Union where the taste in Landscape Gardening is so far advanced, as on the middle portion of the Hudson."[69]

ALEXANDER JACKSON DAVIS

Alexander Jackson Davis (1803–1892) was born in New York and joined Ithiel Town as a draftsman, becoming his partner in 1829. Together, the two men were major contributors to the Greek Revival movement in America. The U.S. Customs House on Wall Street in New York, now known as Federal Hall (1832–44), is an excellent example of their work. Davis is said to have been the more versatile architect and worked in a number of

different styles, including the Gothic, Italianate and the Cottage styles. He was one of the founders of the American Institute of Architects. Davis was a friend of Andrew Jackson Downing, with the two collaborating and setting trends until Downing's untimely death (1852) in a Day Boat accident on the Hudson River. Davis's career declined after tastes changed in the 1860s.

Davis carefully saved and maintained a very complete set of documentation for his work. Apparently, he designed only three buildings for construction in Rhinebeck—Linden Hill, the Delamater House and District 1 Schoolhouse.[70] Other Davis-like designs should not be attributed to him.

South Mill Road, Near Vanderberg Cove, Linden Hill, 1842

The first house in Rhinebeck known to be designed by Alexander Jackson Davis was Linden Hill (Gothic Cottage No. 1). Built in 1842, it was designed for Dr. Federal Vanderburgh in 1841 according to the Davis List of Projects.[71] It was accessed from the south side of the Landsman Kill and sat high overlooking the cove. Dr. Vanderburgh was born in 1788 and was one of New York's first homeopaths. He was attracted to Rhinebeck because his daughter was married to John B. James of Linwood. Living in Rhinebeck

ARCHETYPE: Mill Road, Linden Hill, 1842. *A.J. Davis Gothic Cottage No. 1.*

until his death in 1868, he was described as tall, attractive and beloved. The house was demolished when Fox Hollow was developed in 1910.

6433 Montgomery Street, Delamater House, NR, Village District, 1844

Number 44 Montgomery Street is the most famous Alexander Jackson Davis building in the area. The Gothic Revival–style frame house was designed and built in 1844[72] for Henry Delamater, founder and first president of the First National Bank of Rhinebeck, organized 1853.

Henry Delamater was born in 1800 and died on January 12, 1868. He married Julia Harrison from Connecticut in 1833. Henry began his career as a merchant in Rhinebeck at the White Corner and was town clerk from 1829 to 1830. In the 1850 census, we find Henry and his wife, Julia, with a probable relative, Mary Jane Harrison, seventeen years old, living in their household, along with domestics, Mary Reynolds, twenty-five years old, and Isaac Johnson, a twenty-two-year-old black man.

By the time of the 1860 census, Julia had died but M.J. Harrison, twenty-four years old, was still living in Henry's household. Also in the house were Elihu Jackson, a twenty-two-year-old black coachman, and M. Reynolds, age thirty-five, still in his employ as a domestic.

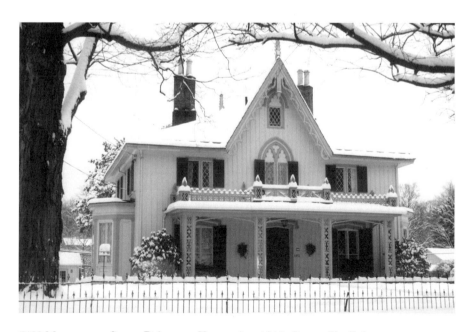

6433 Montgomery Street, Delamater House, circa 1844. *Courtesy Tom Daley.*

Henry must have been justifiably proud of his lovely home, near the center of Rhinebeck, his business and the bank. We can admire the architecture and still feel his influence.

6435 Montgomery Street, Dr. Cross House, Village District, circa 1845

The house just north of the Delamater House on Montgomery Street was owned by Dr. William Cross in 1858. It exhibits Gothic characteristics with a steeply pitched cross gable and arrow-shaped columns. It has been recently refurbished by the Beekman Arms and is now part of the Delamater complex bed-and-breakfast.

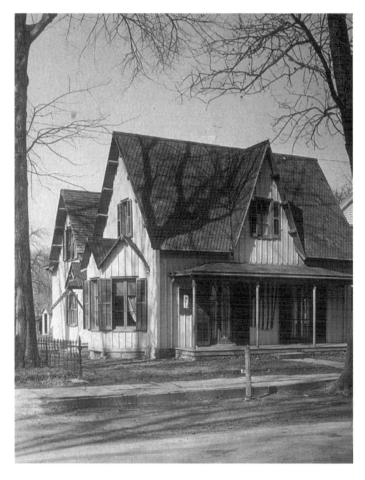

6435 Montgomery Street, Dr. Cross House, circa 1845. *Courtesy Tom Daley.*

Gothic Revival Houses, 1842–1870

96 The Meadows Drive, The Meadows/Leacote, Landmark District, circa 1848

The house at The Meadows—built for Beekman/Tillotson descendants, William P. Wainwright and his brother, Charles Shields Wainwright, about 1848—had Gothic characteristics. Census returns offer a glimpse of the Wainwright household. For example, in the 1850 census, William and Charles were both residing at The Meadows in Rhinebeck. The property was valued at $60,000. There were ten laborers in the household, most born in Ireland. There were also a coachman, groom, waiter, cook and laundress listed. During the Civil War, William Wainwright was a brevet brigadier general and was wounded in battle.

Douglas Merritt, son of George Merritt, the owner of Lyndhurst, Irvington-on-Hudson, which *is* an A.J. Davis design, purchased the property in 1875. He renamed his Rhinebeck property Leacote. He was a trustee of St. Stephen's (now Bard) College, Annandale, and the Starr Institute, Rhinebeck, and an influential member of the community until his death.[73] Masonry stables, a water tower, stone barn and other outbuildings reflect the vitality of the farm under Douglas Merritt.

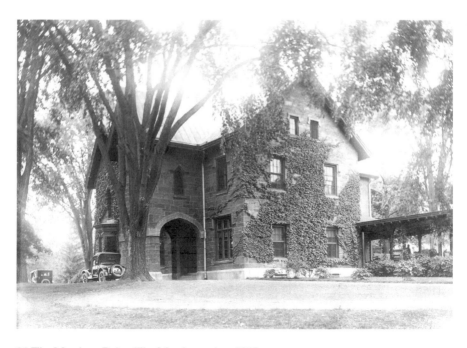

96 The Meadows Drive, The Meadows, circa 1848.

The mansion burned circa 1977. In the years before the fire, as it sat abandoned, it presented a distinctly ghostly appearance. Fortunately, it has been replaced with a new mansion sympathetic to the original design.

42 Crow Hill Lane, Crow Hill, Route 9G and Route 308, 1848

This building, thought to have a Davis influence, was originally called Hill Top and was built for Grace Sands and Rodman Bowne.[74] Building dimensions, casement windows and interior details resemble those at the Delamater House. Grace Bowne, the daughter of the late Robert Sands and widow of John Rodman Bowne, died at Rhinebeck in 1870.[75]

During the period circa 1952–72, Mrs. E. Chase Crowley operated the Crow Hill School at this site. While her son, Richard Crowley, was still young, the house was given a gambrel roof and enlarged to accommodate the school. The loss of Gothic Revival characteristics must have been a cause for regret, since Richard later became an architect, preservationist and Rhinebeck Town Historian. He lived at Crow Hill until his death in 1992.

383 Morton Road, Morton Schoolhouse, District 1, Landmark District, 1842

According to the Davis List of Projects, he designed the District 1 Schoolhouse at the corner of Morton and Mill Roads in 1842.[76] Although

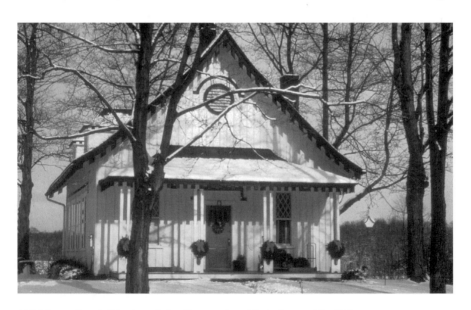

383 Morton Road, District 1 Schoolhouse, circa 1842. *Courtesy Tom Daley.*

it is known as the Morton School, it was built before Morton took residence in town. Davis's notes show that it was designed for Mary Garrettson, whose home, Wildercliff, faces the school on Morton Road. It is a one-and-a-half-story, board-and-batten rectangular structure with a steeply pitched gable roof with a broad bracketed overhang. The façade is arranged symmetrically with a central entrance door flanked by a window on each side. The first-floor windows have diamond panes in the façade. On the side elevation, the windows are six over six. A round louvered window with round arched Gothic label decorates the gable peak.

42 West Miller Road, Miller Schoolhouse, District 11, Route 308

The Miller Schoolhouse, District 11, Route 308, has a similar design and may have copied the Davis design for the Morton Road school. The pitch of the roof and the design of the gable decoration varied somewhat in this building. The bargeboard (carved board attached to the gable edges) decorations have now been removed from the Miller School.

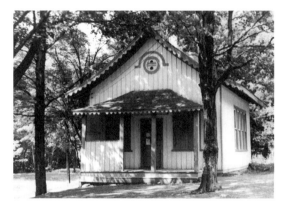

42 West Miller Road, District 11 Schoolhouse.

GEORGE VEITCH

George Veitch arrived in Rhinebeck in 1851. He was born in Waterford, Ireland, July 4, 1826, and died here in January 1885, leaving a wife and two sons. His two daughters—Nannie, nine and a half years, and Katie, fifteen months—had died of diphtheria in February 1862.[77] Mr. Veitch was brought to Rhinebeck to build Wyndcliffe and remained in the Rhinecliff area, designing and constructing many important buildings.

South Mill Road, Wyndcliffe, Landmark District, circa 1851

Surviving only as a haunting ruin, Wyndcliffe adjoined Wildercliff on the south. George Veitch was the architect and builder of this mansion for Elizabeth Schermerhorn Jones. The builder, chosen by Miss Jones, remained in Rhinecliff, leaving a lasting imprint here.

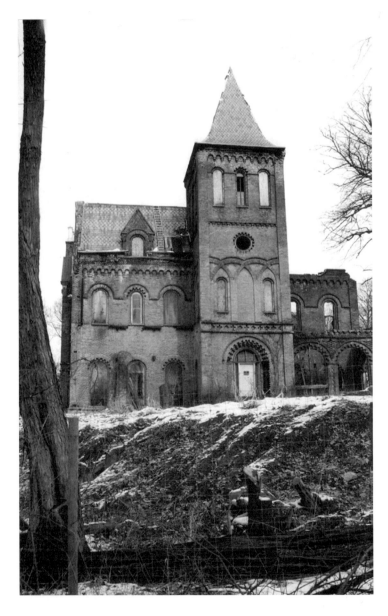

South Mill
Road,
Wyndcliffe,
circa 1851.
*Courtesy Tom
Daley.*

Often considered to be in the Norman Gothic style, the house actually had many Romanesque elements, including the small arches that decorate the cornices and the triple openings of the tower. It was constructed of red brick but was originally painted white.

The family of Elizabeth Schermerhorn Jones, for whom it was built, is said to have given rise to the saying "Keeping up with the Joneses." The house featured a beautiful skylight illuminating a center stairway. In recent years, it became the cause of the ruinous condition of the structure. When it broke and leaked, much of the house was destroyed.

According to the late Stephen Olin, who lived in Rhinebeck at the time, Henry James was a guest of Miss Edith Jones.[78] Elizabeth Jones's niece, Edith Jones Wharton, stayed at Wyndcliffe as a child. Wharton was no friend to the Victorian period. Wyndcliffe was called Rhinecliff in her memoir, published posthumously. In *A Backwards Glance* (1934), Wharton said, "I can still remember hating everything I saw at Rhinecliff…from the first I was obscurely conscious of a queer resemblance between the granite exterior of Aunt Elizabeth and her grimly comfortable home." However, the Willows, the old mansion in Wharton's last novel, *Hudson River Bracketed* (1929), depicts the estate more fondly: "This is what an old house looks like!" the novel's midwestern hero thinks to himself upon seeing the place. As with Henry James, Edith Jones Wharton's art owned much to childhood visits at Rhinebeck.[79]

Under the ownership of A. Finck, the mansion was called Linden Grove, recalling the Vanderburgh place near Fox Hollow. The 1891 Beers Atlas shows the estates—Linwood, Linwood Hill and Linden Grove—grouped close together.

2 Corning Street, George Veitch House, Landmark District, 1865

George Veitch (1826–1885), builder and architect, remained in the area, building himself a house in Rhinecliff at the corner of Corning Street and Dutchess Terrace. The original tower has now been removed. It is sited with a beautiful view of the river, imposing itself on Rhinecliff, the community that George did so much to develop.

He died on January 21, 1885, leaving a widow, Jane E., and his sons, William T. of Oakland, California, and Richard M. of Newark, New Jersey.

A number of other Rhinecliff buildings were designed and built by George Veitch.

3 Mulberry Street, Church, Corner of East Market Street, Village District, 1852

3 Mulberry Street, Episcopal (later, Catholic) church, circa 1852. *Courtesy Tom Daley.*

George Veitch designed and constructed this building in Rhinebeck at the corner of Mulberry and East Market Street in 1852 for the Episcopal congregation. It was purchased in 1901[80] by the Catholic diocese and is now the Church of the Good Shepherd. A steeply pitched roof and tower with pyramidal roof; pointed, arched windows; buttresses; and flared eaves distinguish the building. It originally had a board-and-batten finish but has undergone several renovations and is now clad in cedar shingles.

4 Grinnell Street, Rhinecliff Hotel, Multi-R District, 1852

4 Grinnell Street, Rhinecliff Hotel, 1852.

The Rhinecliff Hotel, built in 1852, is attributed to George Veitch. This building served Rhinecliff during the construction of the railroad and accommodated passengers and railroad workers until 2003. Due to its deteriorated condition, it has been recently rebuilt. The reconstruction preserves the original lines of the exterior and has reused some of the interior trim and materials.

As constructed, the building was a four-story, five-bay, rectangular, clapboard structure with a steeply pitched roof and central cross gable. One-

over-one windows characterized the façade with plain molded sills and lintels and half-story windows under the broadly overhanging, bracketed gable roof. The building was further decorated by a porch with square columns, railing and spandrel decoration, which extended across the façade at the second-floor level.

St. Joseph's Catholic Church, Landmark District, circa 1864

In 1863, land was purchased in Rhinecliff for a Catholic church. The building was designed and built by George Veitch with mason John Bird.[81] Irish workers for the railroad settled in the Rhinecliff hamlet and were well served by the church. One hundred and one steps led up the steep slope to the front of the church, guiding parishioners to God's house. A wonderful photo is found in Croswell Bowen's book, *The Hudson*.[82]

This Gothic Revival church is constructed with a central tower and a slate roof. Aisles flanking the nave have angle buttresses engaged in the corners with Gothic finals. Along the north and south of the upper portion of the nave there are a series of four-pane diamond casement windows. Aluminum siding has obscured the original wooden siding.

EDWARD TUCKERMAN POTTER (1831–1904)
Born in Schenectady, Potter was a specialist in ecclesiastical design. He studied architecture under Richard Upjohn. The Mott–Potter Memorial at Schenectady, 1858, is an example of his early work. He also was the designer of Mark Twain's home in Hartford, Connecticut.

Charles and Orchard Streets, Riverside Methodist Church and Parsonage, Rhinecliff, Multi-R District, circa 1855–1859

This Gothic Revival–style, stone, circa 1855–59 church building is oriented toward Orchard Street. Two large Gothic arched windows at the gallery level flank the entrance. The architect was Edward Tuckerman Potter.

It features a steeply pitched, polychrome slate roof surmounted by an open frame bell tower. Exposed rafters support broadly projecting eaves and the roughly hewn, random-coursed stone construction is highlighted with brick and smooth-faced stone trim. In 1973, the congregation joined with the Methodist church in Rhinebeck and sold the building. It has now been converted to residential space.

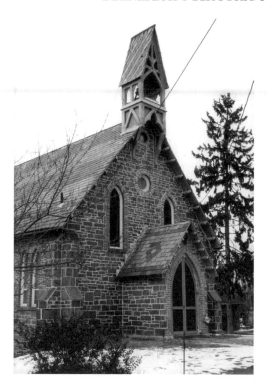

Charles and Orchard Streets,
Riverside Methodist Church, circa
1855–59. *Courtesy Tom Daley.*

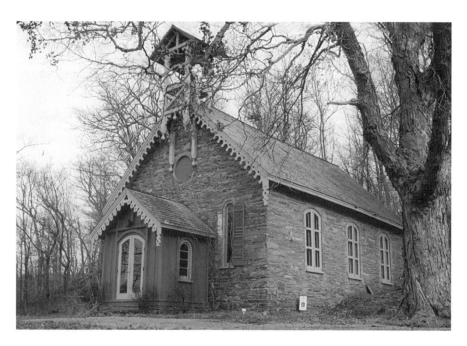

Route 9 South, Hillside Methodist Church, circa 1855. *Courtesy Tom Daley.*

Gothic Revival Houses, 1842–1870

Route 9 South, Hillside Methodist Church, Multi-R District, Landmark District, circa 1855

The picturesque, stone, Gothic Revival–style Hillside Methodist Church was built in 1855 in honor of Mrs. Julia Olin. Edward T. Potter was the designer and the builder was John Brown, who lived nearby. It has a steeply pitched gable roof and broadly projecting, bracketed eaves embellished with scroll-sawn bargeboards. An open framed bell tower with decorative woodwork surmounts the front gable end. The rooflines of the main block are decorated with bargeboards. Both the main roof and the vestibule roof have cutwork pendants at the forward corners.

Although the building has now been adaptively reused for a commercial purpose, the spirit of its founder persists. Julia Olin conducted Sunday school nearby and determined to build the church. Her spirit inspires reverence at this beautiful site.

Mount Rutsen Chapel, Ferncliff Forest, Landmark District, 1883

The Suckley Chapel at Mount Rutsen was also constructed of stone and built in a similar style. It was dedicated on September 29, 1883. Rutsen Suckley conceived and established a retirement community for Methodist ministers there. The community was built with the chapel as a centerpiece. Unfortunately, the chapel was relatively short-lived. When the community failed, John Jacob Astor acquired the land and took down the buildings. Deborah Dows and Laura Delano each used stone from the chapel at their homes.

Heermance House and Law Office, Rhinecliff Road, Multi-R District, Landmark District, 1858, 1866

The Italianate-style cottage features ornamental brackets and pierced woodwork, which provide the Italianate influence for the otherwise late Federal or Greek Revival two-story building. A picturesque veranda spans three bays on the front façade.

The law office (used as such by 1866, though it was used as a house in 1858) is located close to the road, several hundred feet south of the main building, and was presumably built for Martin Heermance. It is sheathed with clapboard and vertical board siding and has a cross-gable roof with projecting eaves, embellished with pierced bargeboards.

The attorney, Martin Heermance, was a descendant of General Martin Heermance, the builder of Elmwood, an early Rhinebeck Village home.

9 Williams Street, Rhinecliff, Church of the Ascension Sunday School, Landmark District, 1864

The Sunday school building at 9 William Street, Rhinecliff, was built for the Church of the Ascension in 1864 through the efforts of Miss M.E. Radcliff and Kate Ardagh. Only a few years later, funds were raised to move the building from its original location on the south side of Williams Street across the street to its present location.[83] It is an extended octagon in shape and has been lovingly restored to become a single-family dwelling.

33 Grinell Street, Free Church Parsonage, Rectory of the Church of the Ascension, Multi-R District, 1869

This parsonage at the corner of William and Grinnell Streets, Rhinecliff, was built for the Reverend Thomas Savage with funds provided as a gift by Mrs. William Starr Miller, benefactor of the library in Rhinebeck. It is a one-and-a-half-story cottage that retains nearly all of its period detailing

9 Williams Street, Church of the Ascension Sunday School, 1864. *Courtesy Tom Daley.*

with paired windows; Gothic gable windows; a steep-pitched, cross-gabled roof; double bay windows; and original board-and-batten siding.

The original front door was a double door and would have opened the house to breezes from the river, but it has been replaced with a single door surrounded by sidelights, allowing the sunshine in and keeping out the cold west winds. The gable windows are crowned with round, arched top panels, divided by Gothic tracery.

Grinell Street, Church of the Ascension, Rhinecliff Episcopal Church, Landmark District, 1871

The Rhinecliff Episcopal Church, known as the Church of the Ascension, was a wooden structure, Gothic in design, located across Grinnell Street from the parsonage. The Ascension church burned but its ruins have been transformed into a garden.

Mill Road, J.W. Moore House, Multi-R District, Landmark District, circa 1850

The Moore House was built as a one-and-a-half-story frame cottage with a cruciform plan and board-and-batten siding. It has many Gothic elements.

Grinell Street, Church of the Ascension, 1871. *Courtesy Tom Daley.*

33 Grinell Street, Church of the Ascension Parsonage, 1869. *Courtesy Tom Daley.*

It is built into a hillside and the exposed stone foundation is covered with stucco. The builder was J.W. Moore, who lived there, but the designer is unknown. This house, also known as West Farm, was associated with the Grasmere property.

Contributing outbuildings include a barn and a carriage house. The barn is embanked into a steeply sloping hillside. It is a large building with a gable roof and exposed rafters under projecting eaves. The carriage house is a rectangular frame building, ornamented with quatrefoil windows and a miter-arched lintel above the carriage entrance.

Quatrefoil windows may be observed in several other area buildings and are a unique feature found in the Rhinebeck area. The leaf-shaped lobes are formed by cusping a circle or an arch.

6460 Montgomery Street, Evergreen Lawn, G.W. Schryver House, Village District, circa 1840

An example of a brick Gothic building, this house has a rear addition in the Second Empire style. There is elaborate cutwork bargeboard, a three-sided bay with diamond-paned windows and some with trefoil design. In recent years, a porch has been enclosed, altering the original lines of the house.

49 South Street. *Courtesy Tom Daley.*

Gothic Revival Houses, 1842–1870

49 South Street, Village District

An excellent example of Gothic Revival styling is located on South Street. It is a two-and-a-half-story, three-bay dwelling with a central, two-story bay projecting from the façade. Windows on the first floor are two over two with plain sills and lintels. The second story has several windows with Gothic arches. There is elaborate cutwork decoration under the eaves on all sides and a central, original chimney. In 1979, it was the home of Fire Chief George Crowley.

2 South Street, The Gables, Village District, circa 1860

Steep gables, with semicircular arches used for window openings, distinguish this fifteen-gabled house on South Street. A carriage barn at the rear enhances the property.

In 1867, Henry Skidmore was living at this location. In the 1865 state census, he is listed as a gentleman, fifty-nine years of age, with wife Eliza, thirty-nine years old, and three children ages seven to fifteen. His mother-in-law and a thirteen-year-old servant are also in the household. He does not appear in the 1870 census in Rhinebeck or elsewhere.

2 South Street, The Gables, circa 1860. *Courtesy Tom Daley.*

ITALIANATE HOUSES,
1852–1877

Prior to the Civil War, Rhinebeck contained solid stone houses and the post-and-beam houses of the original settlers, along with the fashionable Greek Revival homes, built prior to 1850, while the Gothic-style houses provided variety.

After the Civil War, until the advent of the Depression in 1929, Rhinebeck assumed an impressive grandeur. The 1876 map of Rhinebeck shows large homes on spacious lots lining Montgomery Street. They were the residences of businessmen, bankers, lawyers and doctors.

Social life in Rhinebeck was a microcosm of that described in Edith Wharton's *The Age of Innocence*. Mrs. Wharton focused on society in New York City, but she was familiar with Rhinebeck and weaved accounts of visits to Rhinebeck into her books. While the lines were drawn between the estates located on the river and the social life of the village, the customs at the grand village houses were very similar to those of the river people.

The men pursued gentlemanly occupations while the women were engaged in social clubs and church activities. Calling cards were used and dinner parties were common events. Each home employed several domestics and functioned on a strict routine.

Lectures, concerts and other performances were held at the new auditoriums in the Starr Institute and the 1873 Rhinebeck Town Hall. Card parties and men's clubs filled out the social calendar.

The Victorian period lent a whimsical aspect to Rhinebeck, placing grand "wedding cake" buildings along Montgomery and some of the side streets of Rhinebeck. Montgomery Square, the Rhinebeck Animal Hospital and Ruge's Garage replaced at least three important buildings. Fortunately, many still remain to provide a wide diversity of architecture.

The Italianate style presented a statement of well being, with large rooms and a grand stairway in a central hall. Typically, the windows were large

panes in a two-over-two configuration. By the Civil War, the Victorian period was well underway, and census results show that many of the households included male and female servants.

330 Morton Road, Wilderstein, Landmark District, 1852

Thomas Holy Suckley, a descendant of the original Beekman and Livingston landholders, inherited a fortune made by his family's export trade and in real estate. In 1852, he purchased a site on the Hudson River. He and his architect, John Warren Ritch, may have brought the Italianate style to Rhinebeck. It was not long before Ritch's designs in the Italianate style were reproduced in Rhinebeck. Area builders either copied the building or used Mr. Ritch's stylebook of the period, *American Architect, comprising original designs of cheap country and village residences, with details, specifications, plans and directions, and an estimate of the cost of each design.*

The Wilderstein estate adjoins Wildercliff to the north and was originally part of that property. The mansion was later remodeled as a Queen Anne chateau[84] overlooking the Hudson with J.B. Tiffany interiors and landscaping by Calvert Vaux. It is now operated by a nonprofit organization and open to the public for tours.

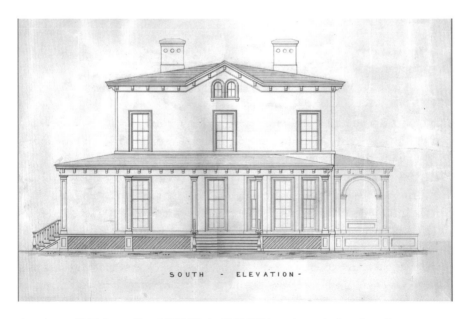

ARCHETYPE: 330 Morton Road, J.W. Ritch, 1852 Wilderstein south elevation. *Courtesy Wilderstein Preservation.*

Italianate Houses, 1852–1877

HENRY LATSON (1814–1885)

Henry Latson was a significant builder in Rhinebeck. His houses span the Civil War and post–Civil War period. Henry's father, Peter, a builder, came to Rhinebeck before 1820, bringing young Henry with him and teaching him his trade.

The 1860 census lists Henry Latson, carpenter, with two apprentices living with him. Peter Latson was also listed as a carpenter in the same census even though he was eighty years old.

Henry was active in village affairs and was an early member of the Masons. In 1866, the *Rhinebeck Gazette* listed results of income returns in Rhinebeck, showing Henry Latson with an income of $509. In comparison, attorney Ambrose Wager's income was $466, while the bank president, Henry Delamater's income for the year was $1,516. (William Kelly of Ellerslie had an income of $16,471, and Elizabeth Jones of Wyndcliffe had $14,539, contrasting the river people with the townspeople.)

The second commercial building from the corner on the south side of East Market Street was the Latson Building. It is one of those discussed later and was built after the disastrous 1864 fire in the commercial district.

An 1873 article in the *Rhinebeck Gazette* described plans to build the town hall on Mill Street. Henry Latson was the contractor.[85]

Henry also built the significant houses of Ambrose Wager and John O'Brien, discussed below under the heading of Gilbert B. Croff's Second Empire house designs.

Henry died in 1885. His wife, Maria, died on December 31, 1898, at her residence on Livingston Street. Both are buried at the Rhinebeck Association Cemetery. They left two sons, John Latson and Dr. Frank Latson.[86]

45 Livingston Street, Latson House, Village District, circa 1866

Henry Latson's home at the corner of Livingston and Mulberry Streets was built in the Italian villa style; however, the tower has now been removed. The house may have been built shortly after Henry constructed the Suckleys' house at Wilderstein. A period barn is located behind the house.

The Catholic congregation selected this land in 1863 to establish a Catholic church in Rhinebeck, but Rhinecliff members of the congregation objected to the Rhinebeck site and the property was sold. Eventually it became the property of Henry Latson.[87] It was not until 1901 that the Good Shepherd Catholic Church was established on East Market Street in Rhinebeck Village.

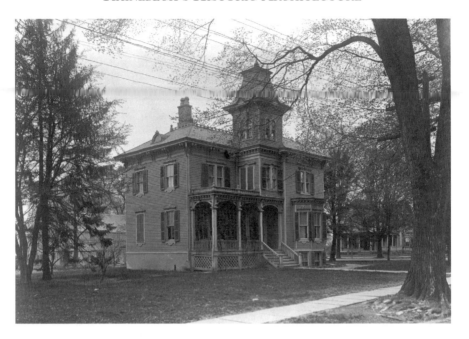

45 Livingston Street, Henry Latson House, 1866. *Vintage Shaffer photo.*

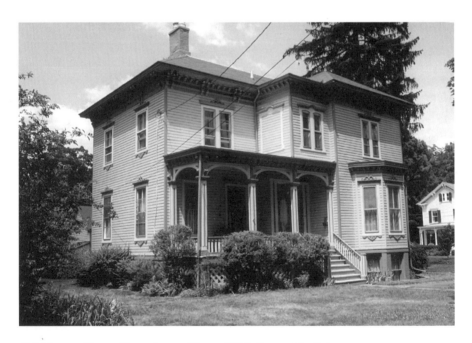

45 Livingston Street, Henry Latson House, 1866. *Courtesy Tom Daley.*

31 Chestnut Street, G. Esselstyn, Village District, circa 1870

A house in the villa style was constructed on Chestnut Street after 1867 and before 1876 for attorney George Esselstyn. He was active in many facets of town life and also served as town supervisor.

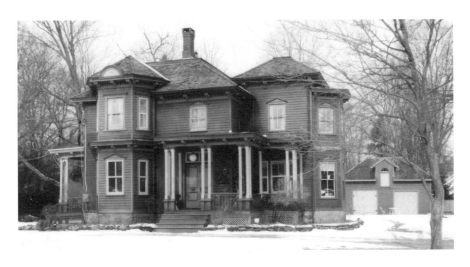

31 Chestnut Street, Esselstyn, circa 1870. *Courtesy Tom Daley.*

It is a two-story, multi-bay clapboard structure with an asymmetrical plan and hip roof with an elaborate modillion and dental cornice. There are projecting tripartite bays on the façade and the east and west elevations.

57 West Market Street, Elmwood, Landmark District, 1793, 1867

A one-and-a-half-story, late Georgian house, built about 1793 by Dr. Hans Kiersted and his son-in-law, Martin Heermance. Hans Kiersted was one of the first doctors in Rhinebeck. He moved to Rhinebeck from Clinton and remained to the end of his life in 1811. Martin Heermance recorded in his family Bible the date of the family's move into their new house—October 19, 1793.[88] John I. Teller became the owner of the house after Heermance. The house assumed its present form as a monumental stucco Italian villa in 1867. The four-story central tower with a flared roof is its most prominent

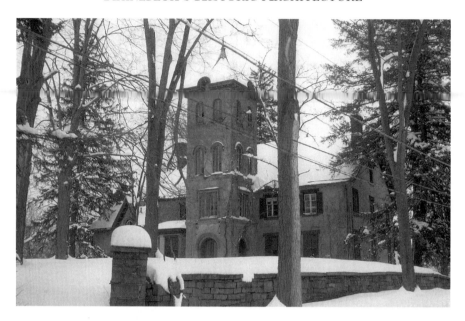

57 West Market Street, Elmwood, 1793. *Courtesy Tom Daley.*

feature. In 1880, Eugene Wells, a direct descendant of Teller, lived there with his wife and his daughter Caroline. They had a twenty-one-year-old Irish housekeeper. Caroline (Carrie) Wells continued to reside at Elmwood throughout her life. Her spirit is felt on the property, which was donated to the hospital to benefit healthcare and affordable housing.

Elmwood is now in private ownership and is currently undergoing reconstruction.

138 East Market Street, Burrell/Quick House, Village District, 1850, additions circa 1890

Various maps of Rhinebeck show a house on this property beginning in 1850. Mrs. Burrell is listed as the owner in 1858.

Smith Quick was probably the owner who made the improvements to update the older house to a Queen Anne style. He was a sash and blind maker and the first grand master at the Masonic Lodge in Rhinebeck. He probably also constructed the large carriage house and barn facing South Street.

The house is distinguished by a deeply projecting cornice with paired brackets and frieze with dentils and panels. A front tower, side bays and a full porch were added to the house after 1890 to achieve a Queen Anne style. The porch features Doric columns and turned balusters.

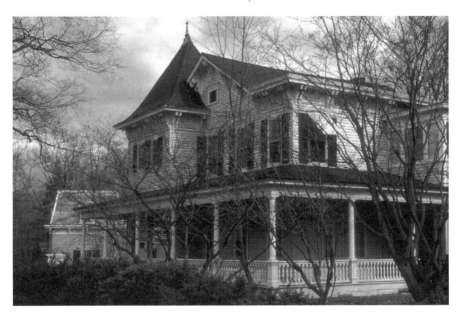

138 East Market Street, Smith Quick House, 1850. *Courtesy Tom Daley.*

781 Route 308, Proper, Sepascot Farm, circa 1862

Built before 1867, this house is a Hudson River bracketed Italianate style. Brackets are used in pairs all around the fascia of the house and also around the porches and the roof of the three-sided bay window. A photo taken on July 3, 1895, shows the builder, Robert Proper, with his family and also includes

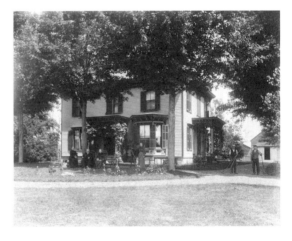

781 Route 308, Sepascot Farm, 1862.

the hired girl and hired hands. Robert is seated with his wife, Margaret Weatherwax, near the front door. They both descended from 1710 Palatine families. The farm was 144 acres when Robert purchased it, and it remained in that configuration until 1986. It has belonged to descendants of Leslie Weaver for the past one hundred years.

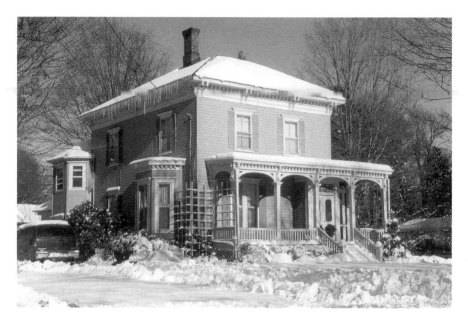

31 Chestnut Street, 1868. *Courtesy Tom Daley.*

31 Chestnut Street, Village District, circa 1868

One of the first houses built on Chestnut Street, the Pink family house, was built in 1868–70. It showcases period detailing including a hipped roof, terminating in a bracketed cornice. Decorative stained glass highlights the front-door enclosure. There is a two-story bay on the right side and a one-story bay on the left. The porch covers the front of the house and continues on the right to the bay window. A curbside hitching post evokes Rhinebeck's horse-and-buggy days.[89]

188 Wurtemburg Road, John H. Traver Farm, Multi-R District, circa 1876

Built about 1867, this property was originally leased to Michel Pultz, and by 1802 it was leased by Chief Justice Morgan Lewis to John Pultz, as shown on a map made on that date. The parcel originally contained 220 acres. At that time, a house and barn were located on the west side of Wurtemburg Road. The Traver family owned this property in 1858, and following economic good fortune at the close of the Civil War, they built the house on the east side of Wurtemburg Road. It has a symmetrical five-bay design. There is a double door entrance with arched panels and transom. Along with at least

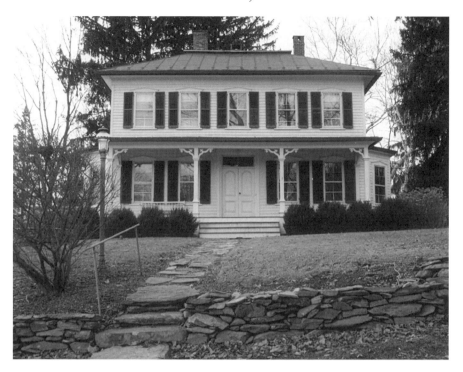

308 Wurtemburg Road, Traver house (metal roof); see similar 188 Wurtemburg Road (shingle roof), 1876. *Courtesy Tom Daley.*

two others on Wurtemburg Road, it features a truncated hip roof and a modest arched architrave over the windows. A wide porch extends across the front of the building. The brackets on the porch pillars also seem to be of the same design as those found on the Wurtemburg parsonage (371), the Traver House (430) and the Brookmeade porch.

220 Route 308, Maplehurst/Brookmeade, 1877

Built by Albert F. Traver, the house was purchased by the first owner, William Thompson, in 1877. Nettie Cookingham, his daughter, inherited the property and left it to her sons, Joe and Bill. During their ownership, it was known as Maplehurst. It was sold in 1950 to Myron Stacks and became known as Brookmeade. Stacks later sold it to the Baptist Home of Brooklyn.

It is an impressive late nineteenth-century classical residence. Features include a truncated hip roof, symmetrical plan, tripartite bay and molded cornice. The only brackets on this house are on the porch pillars. There is

a double front door with a rectangular fixed transom over it. The house has French windows on the front and several bay windows on the sides, including one that is two stories high.

79 Montgomery Street, The Grove, Wager-Van Keuren, Village District, circa 1840

The house known as The Grove was built in the 1840s. Mrs. A. Wager occupied it according to the 1867 Beers map. Ambrose Wager was town supervisor in 1851 and served again in 1864–65. He was also a state senator from 1855 to 1858. It seems likely that this successful attorney built The Grove and subsequently, in 1874, the house on West Market Street known by his name.

The Grove, shown on an 1876 map with an octagon footprint, is a bracketed-style house, noted for its octagonal interior. There are three-sided bays, a cast-iron balcony, a classical porch and a double entrance door. Mr. Wager's sister, Elizabeth, was Mrs. Walter T. Livingston and was the owner in 1891.

The Grove provided an adaptation of Orson Fowler's ideas stressing the benefits of light and circulation in an octagonal building. It was much altered in the twentieth century.

Orson Squire Fowler's book, *The Octogon House, a Home for All*, was published in 1848 and encouraged the building of a number of octagonal homes in the Hudson Valley. Two still stand in Red Hook—the Red Hook Library building and the hexagonal A.J. Davis gatehouse on the Bard College campus.

7038 Route 9 North, Sipperly Lown Farm, Multi-R District, circa 1868

The 1710 Palatine Sipperly family was attracted to Rhinebeck by Henry Beekman. On the 1802 map prepared for Robert G. Livingston, their 144½-acre farm is shown on the Post Road in the northern part of the town and was occupied by Johannes Sipperly. An eighteenth-century house was located on the west side of the road and was later incorporated into the barn complex. An early deed shows that the property was transferred to William Lown in 1846.

The current house on the east side of Route 9 was built circa 1868 and is a Gothic-inspired frame building with many Late Victorian–era ornamentations.[90]

The floor plan is cross-shaped and the building has a cross-gable roof. Oculi with octafoil windows embellish the north, west and south gable ends. Two French doors characterize the façade. A beehive-shaped oven

and fireplace with Federal surround, located in the basement of the east leg of the cross, is evidence of early occupation of the site.

176 River Road, Lorillard House (Ferncliff Superintendent's House), Multi-R District, Landmark District, 1867–1875

Dr. George Lorillard was a member of the Old Gold Tobacco family. He was the stepson of Benjamin van Steenberg and grew up living on the Post Road. He received his medical degree from Albany Medical College in 1847 and served as a surgeon in the Civil War. His medical practice after the war was said to be philanthropic since the tobacco fortune descended to him. He probably built his house on River Road about 1870. It was later incorporated into the Ferncliff estate by John Jacob Astor.

The main block is a two-story Italianate structure with a wraparound veranda. There is a prominent cross gable on each side and a three-ranked façade with a central entrance. The hipped roof includes a flat deck with decorative cresting and two corbelled chimneys.

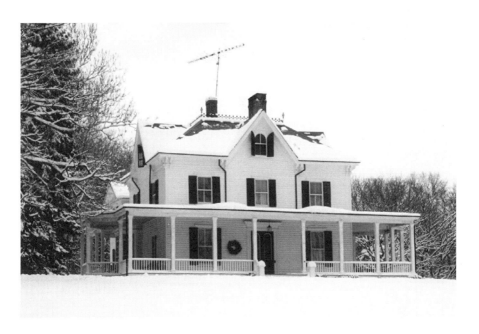

176 River Road, Lorillard House, circa 1870. *Courtesy Tom Daley.*

ROBERT A. DECKER (1843–1916)

Robert A. Decker was born in 1843 and, according to Manorton Lutheran Church records, married Helen Weaver, widow of Anson Coon in 1864. His arrival in Dutchess County before 1867 may be documented by the record of his son Carman's birth and baptism. His wife, Helen Weaver (Coon), died on February 11, 1885, and was buried in her family plot at the Red Hook Lutheran cemetery. Robert was living on Montgomery Street in 1895 when Carman's death is recorded.[91] The house at 8 South Street is labeled "cottage of R.A. Decker" as pictured by the Relief Hook and Ladder Company in *Illustrated Rhinebeck*, published in 1896.

By 1900, Robert was married to Margaret, a native of Germany. He died on February 4, 1916, and is buried at the Rhinebeck Association Cemetery.[92] The legacy of village buildings that he, his son and great-grandson have constructed has had lasting influence on Rhinebeck.

82, 84, 86 and 88 East Market Street, Four Sisters, Village District, circa 1870

Robert A. Decker built a series of bracketed-style cottages on East Market Street, with cross gables and decorative front porches, about 1870. They are located east of the current Rhinebeck Town Hall. Known as the Four

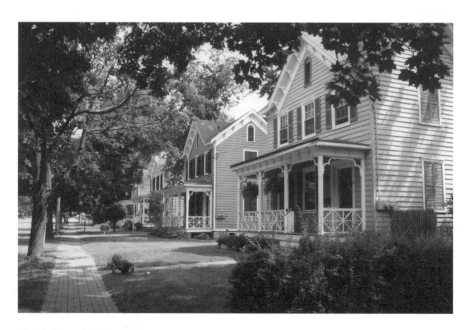

82, 84, 86 and 88 East Market Street, the Four Sisters, circa 1870. *Courtesy Tom Daley.*

Sisters, they retain many of the original details and complement each other handsomely. Houses built in a row in other portions of the village and in surrounding communities could learn much about the value of complementary paint, landscaping and ornamentation from studying these buildings.

In 1876, 82 East Market Street was the home of Howard Morse. He was an attorney who wrote the history of Rhinebeck in 1908. His L-shaped property extended behind the Center Street houses to include frontage on South Street. His dedication to Rhinebeck in studying its history and participating in community affairs is reflected in his book.

COMMERCIAL BUILDINGS

In 1864, the great fire in Rhinebeck leveled the block on the south side of East Market Street and resulted in a row of new buildings, which were the impetus for corresponding buildings on the north side of the street. This series of brick commercial buildings with Italianate influence was built after that May 8, 1864 fire.

2–22 East Market Street Commercial Buildings, Village District, 1865–1869

An article in the *Rhinebeck Gazette* of September 8, 1869, said, "The building now being finished is 50x46 feet, three stories high and of brick and iron. It is owned by Mr. Vanderlind of Poughkeepsie. It has two handsome stores fronting on East Market Street. The interior of the building is being finished in elegant style, and the whole will cost about $12,000." This building is now occupied by the Rhinebeck Smoke Shoppe on the corner with a restaurant to the east.

Farther east, the Latson Building adjoins it and carries an 1865 date beneath the rear stairway. It is distinguished by a molded cornice, a frieze with paired brackets and panels, cast-iron lintels, bluestone sills and a bracketed first-story cornice and frieze. The building was sandblasted circa 1974.

The Van Steenberg building is located at 16–18 East Market Street and the Carroll Building is at 22 East Market. All exhibit similar styling.

1 East Market Street, Village District, 1875

The 1875 building on the northeast corner of the intersection at 1 East Market Street is of brick and is in the Italianate tradition with heavy cornice and brackets.[93] It helped to balance the new construction of the previous decade on the south side of East Market Street.

19 East Market Street, Judson Building, Village District, circa 1858

The Judson Building at 19 East Market Street was built about 1858. It is a three-story commercial brick building with highly decorative cast-iron sills, lintels and columns and reflects the style of the time.

20–22 West Market Street, Village Firehouse, Village District, 1858

About this same time, the first village firehouse was constructed at 20–22 West Market Street. It is a bracketed-style brick building that originally had a tower with a fire bell. Deeply projecting cornices distinguish the building. It served as a firehouse until 1970, when the new firehouse was built on East Market Street.

6417 Montgomery Street, Starr Institute, Village District, 1862

The Starr Institute was built on Montgomery Street in 1862. It is a brick commercial structure in the Victorian Gothic style. There is a central, two-story pavilion, double entrance doors and six-over-six windows, with a classical porch originally built with balustrades on the porch roofs. In 1906, it was remodeled and became a YMCA branch with an indoor swimming pool, which was removed in 1973. The assembly hall was converted to a cinema circa 1939.

Given as a library and community hall to the citizens of Rhinebeck by Mrs. William Starr Miller, it served those functions until 1975, when a new community center was built.

CHAPTER 8

Second Empire Houses, 1871–1880

The Second Empire style (1860–80) was French in origin and was particularly influenced by the additions to the Louvre in the 1850s by Visconti and Lefuel and the Paris Opera by Charles Garnier. The style, named for the reign of Napoleon III (1852–70) became popular for public and residential architecture.

In this time period, walnut was preferred for balustrades and the newel posts on stairways. The evolution taking the Italianate to the Second Empire style was characterized by the mansard roofline. The steeply sloping sides of the roof rise to a flat- or shallow-pitched deck, providing the building with an additional floor containing convenient living space. Cast-iron or decorative cresting drew the attention upward.

29 Livingston Street, DeGarmo Institute building, Village District, circa 1871

This style seems to have begun on Livingston Street in Rhinebeck, where the DeGarmo Institute took the form in 1871. Professor James M. DeGarmo had purchased the Rhinebeck Academy in 1860 and reestablished the school on Livingston Street, where it provided a classical education for area students. The Second Empire–style building was enlarged by DeGarmo after several years and was later used as a hotel and for apartments before its demise. During the postwar period of the 1940s and 1950s, its vacant hulk was a specter. After it was demolished, the land became a part of the Third Lutheran Church property.

An 1890 bird's-eye view of Rhinebeck Village. *Courtesy L.R. Burleigh, Troy, New York.*

ARCHETYPE: 29 Livingston Street, DeGarmo Institute, circa 1871. *1896 etching.*

Livingston Street, Rider House, circa 1871

The Second Empire–style residence on Livingston Street was the home of Albert L. Rider. It was probably built by Henry Latson. Mr. Rider was successful in business as a tanner and a contractor and settled in Rhinebeck in 1871. His house, with its impressive tower, announced his importance. He and his son-in-law, John O'Brien, built part of the Delaware and Hudson Canal and the Rhinebeck and Connecticut Railroad. The structure is no longer standing.

58 River Road, Astor Gatehouse, Landmark District, circa 1879

Hans Jacob Ehlers, was the manager of an arboretum at Kiel in Germany when he was introduced to William B. Astor, owner of Rokeby in Red Hook. He was persuaded to come to the Hudson Valley and employed to landscape Rokeby. Soon, he began work at Ferncliff, landscaping the estate of William B. Astor Jr., son of the owner of Rokeby.[94]

Ehlers's son, Louis Augustus, designed the original Ferncliff gatehouse, circa 1879, built of stone and brick in the Second Empire style. It includes a mansard roof and an irregular T-shaped plan. Originally, adjacent to the entry was a stone canopy, which extended to stone piers.

58 River Road, Astor Gatehouse, circa 1879. *Courtesy Tom Daley.*

The roof includes large wall dormers on each side with projecting cornice and returns. Recently, a large addition has been tastefully attached to the north of the building.

27 South Street, Edward Smith, Village District, 1880

About 1880, Henry Latson built the Smith house at 27 South Street. The original owner, Edward M. Smith, was editor of the *Rhinebeck Gazette*. Shortly after his new house was built, he wrote and published *Documentary History of Rhinebeck* (1881).

As it now stands, it is a modest-sized house with a mansard roof and pedimented lintels. It has been beautifully reconditioned.

GILBERT BOSTWICK CROFF (1841–1909)

Second Empire styling was employed in Rhinebeck for at least two imposing houses designed by Gilbert B. Croff. He was a Saratoga architect, also known to have designed the New York Pavilion at the 1876 Centennial Exposition in Philadelphia. His book, *Progressive American Architecture*, includes the design for the Wager House built on West Market Street in Rhinebeck. With the publication of his book, Mr. Croff encouraged clients to purchase plans including specifications and bills of material, conducting a large part

of his business by mail.[95] He was born in South Wallingford, Vermont, and married Eliza Taft in 1861. He died in Rutland, Vermont.

54 West Market Street, Ambrose Wager House, Village District, 1874

Mr. Croff must have come to the attention of Rhinebeck attorney Ambrose Wager before the time of the Centennial Exhibition, since the house he designed for Mr. Wager on West Market Street was built circa 1874.[96]

The three-story, mansard, frame dwelling is asymmetrical in design. It includes quoins at the first-story corners, while the second story is finished with engaged pilasters. There is a four-story tower. A balcony with hood is located on the left side of the tower on the third floor. Mr. Wager was an attorney in Rhinebeck. According to the 1867 map of Rhinebeck, he probably lived first at The Grove on Montgomery Street. His law office was on East Market Street before the 1864 fire; thereafter, his name was associated with the Greek Revival law office on Montgomery Street. He was town supervisor in 1851 and a member of the New York Assembly from 1855 to 1858. His house, built on the hill overlooking Rhinebeck Village, certainly attested to his success and social prominence.[97]

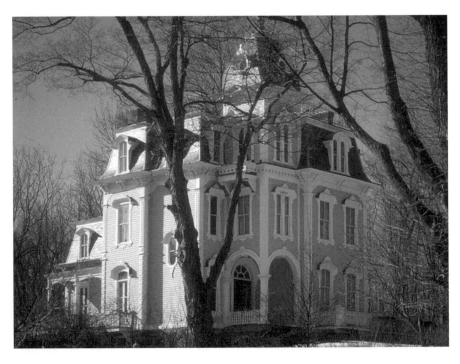

54 West Market Street, Ambrose Wager House, 1874. *Courtesy Tom Daley.*

In the 1880 census, Ambrose was living in the house with his wife, Eliza, a son and two daughters. A twenty-eight-year-old Irish housekeeper was also residing there. Mr. Wager died on June 16, 1883.

The house has often been called the Addams Family house.[98] It stood deserted for a number of years during the time when *The Addams Family* TV show was popular and it haunted the local imagination. The house was sold with a façade easement and underwent extensive restoration by Italian artisans.

46 Livingston Street, John O'Brien House, Village District, 1875

The John O'Brien house was built circa 1875 by Henry Latson[99] at the corner of Livingston and Mulberry Streets. It was the first house in the village to use gas lighting.[100] This three-story, Second Empire–style house was designed by Gilbert Croff and features a mansard roof, gable dormers, decorative overhang and a tower with iron cresting. It was built as a wedding gift and given to Mr. and Mrs. O'Brien by Mrs. O'Brien's father, Albert L. Rider. Mr. Rider and Mr. O'Brien were engaged in a construction business, building canals and railroads in several places in New York. The Rhinebeck and Connecticut Railroad, which ran from the Hudson River through Rhinebeck and then on through Red Hook to New England, was one of their projects.

During World War II, the house was broken up into apartments. A tenant at that time said that the ghost of John's wife, Sara Lena, was seen. Sara died only ten years after the house was built, leaving six children, with one child less than one month old.[101] It is easy to believe that her spirit haunted the house.

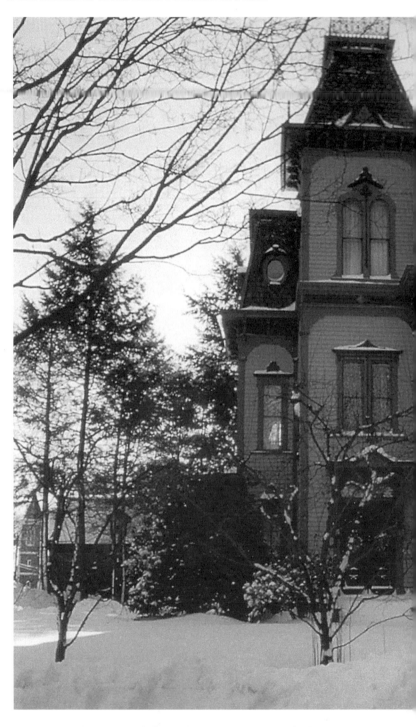

46 Livingston Street, John O'Brien House, 1875. *Courtesy Tom Daley.*

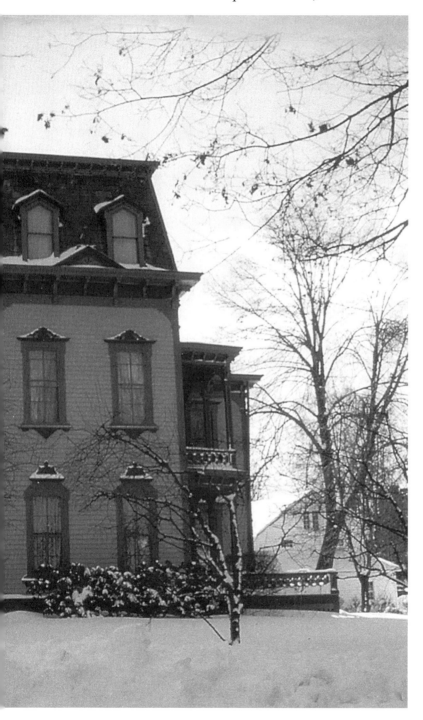

LATE VICTORIAN HOUSES (QUEEN ANNE, EASTLAKE, SHINGLE), 1888–1914

The June 28 issue of the 1890 *Rhinebeck Gazette* stated that Rhinebeck had more millionaires for a little county town than any other place of its size in the country:

> *On the north road* [River Road] *there were Astor, Delano, Merritt, and Cruger. On the South Road* [Morton Road–South Mill Road and Staatsburg] *there was Morton, Suckley, Dinsmore, Huntington, and Livingston. To the West lived Wager and Wells and to the East, Miller. In the village lived O'Brien, J.A. Van Steenbergh, M.V.B. Schryver, Edgerly, Olmstead, Reed and Isigias* [sic].

Fashion of the period dictated elegant millinery for the women and stiff collars for the men. House style reflected the rich detail that was expected.

QUEEN ANNE STYLE

ARNOUT CANNON JR. (1839–1898)

Arnout Cannon was a prominent builder and contractor in Poughkeepsie. His son, Arnout Jr., learned the building trade from his father and studied in the architectural office of Frederick Diaper in New York City before 1862, when he began his own business in Poughkeepsie. He designed important buildings in Poughkeepsie, including the Vassar Institute and the Nelson House Annex.

330 Morton Road, Wilderstein, Landmark District, 1888

When Robert Bowne Suckley inherited his father's fortune and the house at Wilderstein, he immediately arranged for architect Arnout Cannon Jr. of Poughkeepsie to redesign the house. The result, in 1888, was the Queen Anne–

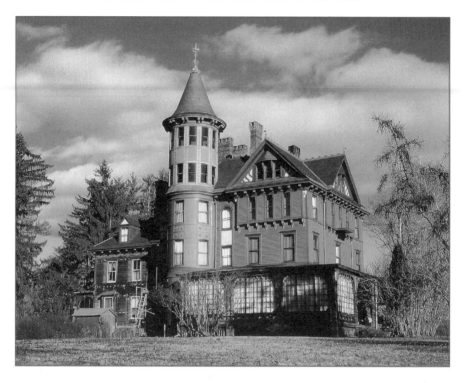

ARCHETYPE: 330 Morton Road, Wilderstein, 1888. *Courtesy Tom Daley.*

style structure we now see on Morton Road. Cannon had been a commander of black troops during the Civil War and was an able manager of the Wilderstein project.[102] The design included a five-story tower, a third-story and gabled attic that overhung the original building and a two-story addition with an attic service wing to the north, plus verandas to encircle the house on three sides. Joseph B. Tiffany was commissioned to supervise the interior decoration.

In 1895, improvements (including office space) were added to the building. At the same time, Cannon designed and built a massive carriage house with a stable and a boathouse for the property.

By 1897, financial reverses encouraged the family to spend more time in Europe, where living arrangements were cheaper. They remained for a full decade. Robert's daughter, well known to the townspeople as Daisy Suckley, lived out her long life at Wilderstein, donating the property to the Wilderstein Preservation organization. The Suckley legacy of imaginative architecture and carefully preserved family records provides a trove of resources for study of the era, the family and the region. The house is maintained as a museum and is open to the public.

Late Victorian Houses, 1888–1914

23 Mulberry Street, Village District, 1893

The World's Columbian Exposition of 1893 in Chicago was a triumph of academic classicism and a major impetus for the City Beautiful movement.

The two-and-a-half-story, Queen Anne–style house at 23 Mulberry Street was built in 1893 from plans for "the ideal house" at the Columbian Exposition. It is noted for its interesting shingle designs, a polygonal tower, decorative windows and veranda. There is a period carriage house on the property.

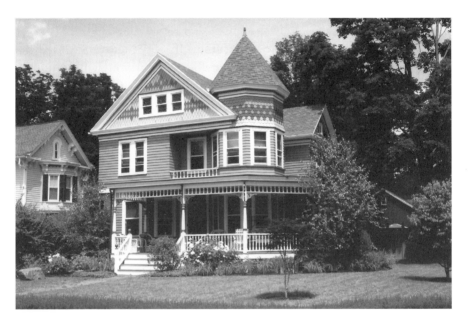

23 Mulberry Street, 1893. *Courtesy Tom Daley.*

48 Livingston Street, Village District, 1895

A two-story, three-bay, Queen Anne–style house was built at 48 Livingston Street about 1895. It boasts a decorative molded entrance door surrounded with sidelights. The second floor has two projecting bays. The house is styled with a balustrade hip roof and molded cornice and frieze.

25 Chestnut Street, Queen Anne, Village District, circa 1895

The house at 25 Chestnut Street is a two-and-a-half-story building with the gable end facing the street and a cross gable. It is a clapboard, three-bay plan with decorative shingle work on the second-story façade and a period porch with decorative cutwork and Eastlake-style spindle decoration on the porch façade.

22 Old Albany Post Road, Renzelver, Landmark District, 1902

A 1902 Queen Anne building is located on 3.5 acres on Old Post Road. The house was known as the "Renzelver Inn." For many years, Hazel Schryver conducted a school for girls at this location. In 1988, it was awarded the Rhinebeck Historical Plaque for "meticulous and thorough restoration." This house features breathtaking Hudson River and Catskill Mountain views. There are eight fireplaces.

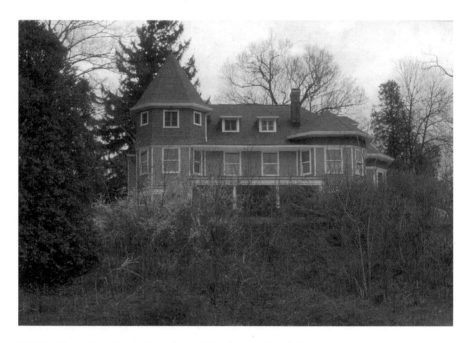

22 Old Albany Post Road, Renzelver, 1902. *Courtesy Tom Daley.*

Late Victorian Houses, 1888–1914

EASTLAKE STYLE

Eastlake is actually named for an English theoretician who espoused the Gothic. It is distinguished by various elements, which often include columns of piers drilled, incised, shaped or proportioned for a novel aesthetic effect. These decorative components were mass-produced by mechanical lathes and jigsaws. It is often confused with the Queen Anne style.

41 Livingston Street, Village District, circa 1870

A circa 1870 house at 41 Livingston Street has many original features. It is a two-story, three-bay house with molded cornice, decorative shingles in a gabled peak and molded door surrounds that are typical of this style, but the detail along the cornice of the front porch provides the most context.[103]

19 Chestnut Street, Village District, 1895

The 1895 Schell house at 19 Chestnut Street has Eastlake detailing. It is an elaborate Victorian two-and-a-half-story house with cross gable, notable

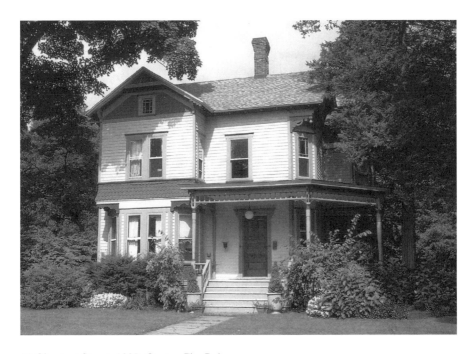

19 Chestnut Street, 1895. *Courtesy Tom Daley.*

for its shingle and cutwork decoration. One-over-one and two-over-two windows are used throughout. The period porch has Eastlake-style spindles. Much of the interior Eastlake detailing remains intact. Behind the house is the original period barn and carriage house.

The progenitor of the family, Christian Schell, came to Rhinebeck shortly after the Revolution. He was an entrepreneur, eventually building the "White Corner," center of Rhinebeck business in the first half of the nineteenth century.

15 South Street, Village District, circa 1880

This house is elaborately decorated with shingle work on all sides and intersecting gables. Decorative elements include fans, sunbursts and cutwork details. P.J. Ackert owned the site, as shown on maps from 1867 and 1876. He may have been the builder circa 1880.

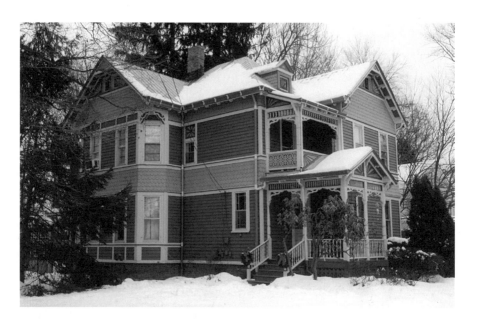

15 South Street, circa 1880. *Courtesy Tom Daley.*

Late Victorian Houses, 1888–1914

THE VIOLET INDUSTRY

This period coincides with the height of the violet industry in Rhinebeck. Violets came to Rhinebeck with George Saltford. Howard Morse, the author of *Historic Old Rhinebeck*, labeled the culture of violets "epidemic" in Rhinebeck. By 1907, it must have seemed that everyone was commercially involved in raising violets. Greenhouses commonly held five thousand plants. The standard violet house was said to be 150 feet long and 20 or 24 feet wide. At one end was the boiler and coal bin. Heating pipes ran around the walls and through the middle of the house. Aisles were just wide enough to walk through.

Tending the plants required the workers to lie on boards, suspended over the beds. Plants had to be set out, and later, when the flowers were ready, they were meticulously picked by hand. During the height of the season, schoolchildren were given a holiday because everyone was needed to provide the flowers required for Easter.

The violet bouquet or bunch was made up of many flowers encircled with leaves. It was a formal arrangement, well suited to the Victorian costumes of the day. A lady would often wear a bunch of violets tucked into her sash.

The Gilded Age saw the height of the violet industry in Rhinebeck. As the occupation became more popular, the violet kings acquired the wherewithal to build new homes.

17 Platt Avenue, Ethan Coon House, 1917

The house at 17 Platt Avenue was built in 1917 for Ethan A. Coon. He was known as the "violet king," since in 1912 he owned 27 greenhouses out of a total of 112 in the town. His house was built in the Foursquare style with a pair of projecting two-story bays and a wraparound porch with turned wooden columns. The main entrance is located on the east side of the house and does not face the street.[104] The Foursquare was a simple box-shaped, two-and-a-half-story-high building with a low-hipped roof and wide porch and stairs with a four-room floor plan.

See "violet king" Julius von der Linden House, 10 Platt Avenue, under the Arts and Crafts heading.

ROBERT G. DECKER
Robert G., the son of builder Robert A. Decker, was a prolific builder of fine homes in the village of Rhinebeck. Early survey maps show properties that he owned and probably developed. Extensive deed research could reveal much more about his activities.

In 1897, Robert G. Decker bought three College Hill lots. This property was located on the Schryver estate, bitterly contested in the opening of Livingston Street. The "hill" was leveled and Robert probably built the houses on these lots. Perhaps the culmination of his career was the 1938 building of the new town hall at 80 East Market Street in Rhinebeck. His grandson, Gary Decker, continues the family tradition of builders of fine homes.

Another relative, Roy Decker, developed Locust Grove Hill, west of Montgomery Street.

62 Livingston Street, Village District, circa 1886

Robert G. Decker built 62 Livingston Street about 1886. Prominent features of the house include the Gothic-style porch spandrels, the unusual decorative shingle pattern in the gable end and fish scale shingles.[105]

69 South Street, Village District, circa 1900

The circa 1900 house at 69 South Street is attributed to Robert G. Decker. It is a complex design—a two-story, four-bay plan with a two-story polygonal tower. There is decorative shingle work with clapboarded siding.

SHINGLE STYLE

ACKERT & BROWN

Ackert and Brown were members of the Hillside Church and probably lived south of the village. William C. Ackert was born in December 1854 and was listed in the 1900 census as a carpenter. His son, Lewis, also worked with him. John C. Brown was born in February 1837. He is found in the 1900 census, listed as a carpenter.

26 Old Albany Post Road, Stonecrest, Multi-R District, Landmark District, circa 1905

The firm that built and probably designed this building was Ackert & Brown, which contracted to do the work for George D. Beatty, in whose family it remained until 1930. Stonecrest is Shingle style, relating to American colonial architecture. This style has been described as redefining picturesque taste by avoiding English influences and plans to achieve a more relaxed, organic American design. Distinctive characteristics of this style include a multi-gabled roof with prominent cross gables, dormers and towers and the natural appearance of stone and wood. A service wing and porte-cochère (a

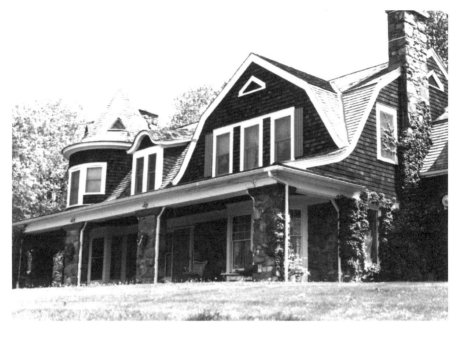

26 Old Albany Post Road, Stonecrest, circa 1905.

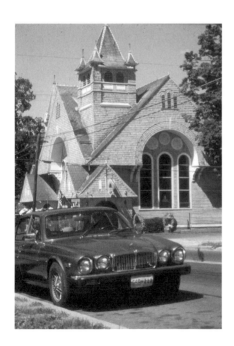

6426 Montgomery Street, Baptist church building, circa 1890. *Courtesy Tom Daley.*

drive-through entrance porch) flank the main block.

In the interior, a large cobblestone fireplace with an "S" inlay is complemented by the staircase. There is a tripartite window on the landing.

6426 Montgomery Street, Baptist Church Addition, Village District, circa 1890

The Shingle-style addition to the original Baptist church at the corner of Livingston and Montgomery Streets greatly enlarged the small 1823 chapel. Constructed circa 1890, the addition is distinguished

by a square bell tower and heavy projecting gables with arched recesses for three quatrefoil windows above tall, arched windows. Brackets support the gables. The entrance porticos have similar projecting gables with arched openings and paneled doors. The Baptist congregation sold the building in 1977 to build a larger structure with a large parking lot. The building is now adaptively reused as a restaurant.[106]

ECLECTIC HOUSES (TUDOR, SPANISH REVIVAL, BEAUX ARTS, CRAFTSMAN), 1880–1948

At the end of the nineteenth century, European-trained architects began to design period houses for wealthy clients. These were mainly in the Beaux Arts, Tudor or Colonial Revival styles. In Eclecticism, inexpensive techniques for adding a thin veneer of brick or stone to balloon-framed houses allowed even modest cottages to mimic Old World landmarks. Virginia and Lee McAlester, in their *Field Guide to American Houses*, said, "The resulting burst of period fashions drew on the complete historical spectrum of European and Colonial American housing styles and dominated domestic building during the 1920s and '30s."[107]

TUDOR STYLE

Sometimes considered a version of the Queen Anne style, the Jacobean or Tudor emphasizes diagonal bracing and heavily carved trim.[108]

RICHARD MORRIS HUNT (1827–1895)
Richard Hunt, who trained at the École in France, 1846, established the eclectic Beaux Arts tradition in the United States and helped found the American Institute of Architects (1857). He was commissioned by Levi P. Morton to design a new mansion at Ellerslie. Hunt had previously built a ballroom for Morton's Newport house and a stable for his house in New York City.

10 Holy Cross Way, Ellerslie, designed in 1885, completed 1888

Levi P. Morton came to Rhinebeck just prior to his election as vice president of the United States. He served with President Benjamin Harrison. He made plans to remove the William Kelly Home and employed Richard Hunt to

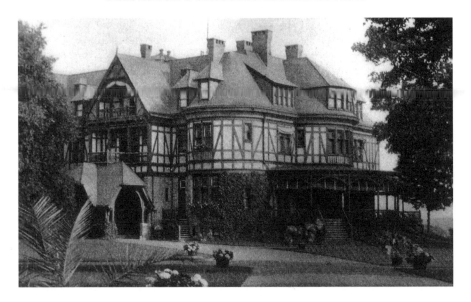

10 Holy Cross Way, Ellerslie, 1888. *Courtesy Tom Daley.*

design a new mansion. The style of the new Ellerslie was not typical of Hunt's work. It is thought to have been at Mr. Morton's suggestion that this Tudor-type building was designed. Richard Morris Hunt later designed The Breakers in Newport, Rhode Island, for the Vanderbilts.

During the 1940s, the Ellerslie mansion became the site of the Cardinal Farley Military Academy. A fire destroyed the mansion on October 20, 1950.

6339 Mill Street, Astor Home for Children, Multi-R District, Landmark District, 1914

This institutional building with Jacobean Revival–style features is described under the heading of Harrie T. Lindeberg, Astor Home.

JOHN RUSSELL POPE (1874–1937)

John R. Pope was the son of a successful portrait painter. He studied architecture at Columbia University. Mr. Pope designed the National Gallery of Art and many classic public buildings but is best known for his design of the Jefferson Memorial (completed in 1943). A Tudor-style mansion that he designed in 1916 in Richmond, Virginia, for Richard Branch now houses the Virginia Center for Architecture.

Eclectic Houses, 1880–1948

Delano Drive, Evergreen Lands, Laura Delano House, Multi-R District, Landmark District, circa 1932

Located on Delano Drive in Rhinebeck, this house was designed by architect John Russell Pope. It was intended as a caretaker's lodge for a mansion that was never built due to the effects of the Great Depression.

The house built for Miss Laura F. Delano is fashioned in the English Tudor style, with formal cut stone, stucco and timber construction. Irving Staley was the general contractor.

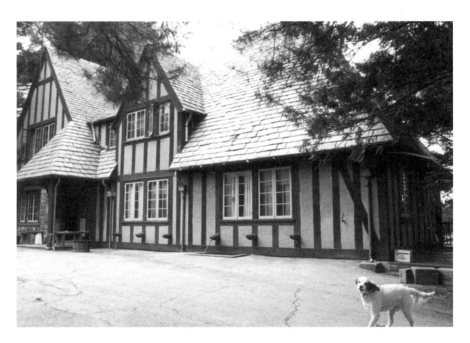

Delano Drive, Evergreen Lands, circa 1932.

There are 2,500 square feet of living space and a garden room with attached greenhouse. It has a slate roof and two fireplaces.

Following the suggestion of her first cousin, Franklin D. Roosevelt, Laura personally selected and transported stone for her house from the ruins of the Mount Rutsen Chapel. FDR often visited Laura. The house is located only a few miles north of Hyde Park, allowing Roosevelt to drive himself for visits using his hand-controlled automobile. An apparition of Laura with her recognizably "purple" hair has been reported at the house.

SPANISH REVIVAL

Revivals of various styles were popular in the first third of the twentieth century. Period houses of this type—such as Spanish Colonial and Colonial Revival, as well as Italian Revival architecture—are identified with the decorative vocabulary of the earlier period.

South Mill Road, Whispering Pines, Stein House, Landmark District, 1906

This 1906 house is an example of Spanish Revival with a typical clay tile roof. The two-story, Mission-style house includes a main block with a wing at an oblique angle and a prominent porte-cochère. It is covered with smooth-faced stucco. It was probably built for New York realty broker Conrad Stein and was later occupied by concert pianist/humorist Henry L. Scott.

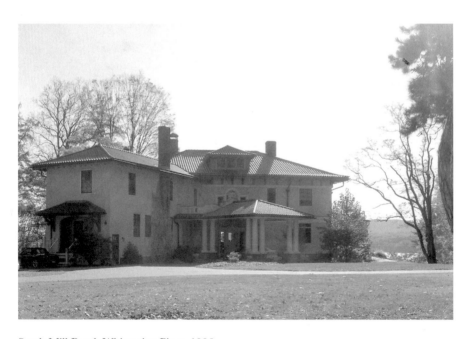

South Mill Road, Whispering Pines, 1906.

Eclectic Houses, 1880–1948

Hutton Street, Rhinecliff, Rhinecliff Railroad Station, Landmark District, 1904, 1910–1914

The Rhinecliff Station of the New York Central Railroad was built in the Mission or Spanish Revival style similar to the nearby Hyde Park station. The designers were Warren & Wetmore, who also designed Grand Central Station (see the discussion about these architects with the description of Rockledge). It is a buff-colored brick building in a cruciform plan with extensions to the north and south. There is a Spanish tile ceramic roof.

Millionaires John Jacob Astor and Levi P. Morton influenced the design of the building and contributed to its construction. The resulting building is much larger than usual for a small hamlet.

ACADEMIC CLASSICISM OR BEAUX ARTS STYLE

Academic Classicism (1885–1920) is also referred to as the Classical Revival or Beaux Arts Classicism (after the École des Beaux-Arts in France). It is described as a late form of Neoclassicism, with a decidedly eclectic flair. Greek and Roman forms are combined with Renaissance ideas.

McKim, Mead & White

Charles McKim (1847–1909), William Rutherford Mead (1846–1928) and Stanford White (1853–1906) were partners in an influential architectural firm that employed almost one hundred people. White had worked in the office of Henry Richardson, where he became acquainted with the other partners who formed his new firm. (Stanford White was born in New York in 1853 and died in New York on June 5, 1906.)

"The success of the firm was said to be due to the complementary nature of the three partners—McKim the idealist, Mead the pragmatist, and White the sensualist."[109]

White's career was varied. He designed both summer homes for the rich and famous and such formidable structures as the Washington Square Arch, Madison Square Garden and the New York Herald Building.

In 1896, Stanford White designed the Mills mansion called Staatsburgh House for millionaire philanthropist Ogden Mills and his Livingston wife. It is a sixty-five-room Beaux Arts palace. Located south of the town of Rhinebeck, the early owner of the property was Morgan Lewis, who had also owned the majority of the property south and east in Rhinebeck.

White's career was brief, ending with his murder by Harry K. Thaw over an affair with Evelyn Nesbit.

River Road, Ferncliff Tennis House/Casino, Landmark District, 1904

The Casino or Tennis Court House, styled after the Grand Trianon at Versailles, was designed by McKim, Mead & White in 1902 for John Jacob Astor and his wife, Ava Willing.[110] Constructed in 1902–4, the beautiful lines of the building are typical of White's best work. Records of the architectural

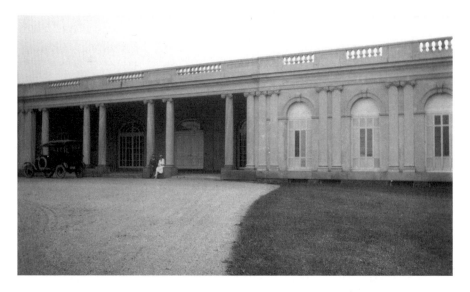

River Road, Ferncliff Casino, 1904. *Courtesy Tom Daley.*

firm now in the archives of the New York Historical Society show that the building cost $238,126.[111]

The Astors could look out at their various yachts from this building. The favorite of Vincent Astor, John Jacob's eldest son, was the *Nourmahal*. Before World War II, he was able to sail anywhere in the world on his yacht. About 1942, he gave it to the government to further the war effort.

The building included an indoor tennis court, squash court, bowling alley and indoor heated swimming pool, resplendent with arched windows and marble columns. The squash court has now been converted to a library. The tennis court is enclosed under a high, well-lighted vault of Gaustavino tile.

Recent property owners have accomplished splendid restoration.

500 Route 308, Dr. George Miller's Carriage House, Multi-R District, 1892

The carriage house was constructed in 1892 for Dr. George N. Miller Jr. as a part of the Schuyler House complex (The Grove). Charles Atkins, owner of the carriage house at the time of the 1984 National Register Survey, had the architectural drawing from McKim, Mead & White in his possession.

The carriage house is an asymmetrical, roughly C-shaped brick building in a Georgian-inspired style. Stall areas are indicated by a series of nine four-paned windows along the north wall. It has been converted to a residence, with carriage doors largely replaced by windows. The slate roof is steeply pitched with a large cross gable and gable-roofed dormers set with windows that have rounded tops and pointed arch tracery. Single round arch windows with gauged brick surrounds are featured in all gable peaks. In the north wall, three French doors with glazed eight-light transoms provide a focal point on the first-floor façade. The carriage room had an elevator system to lift unused vehicles to the second floor for storage.

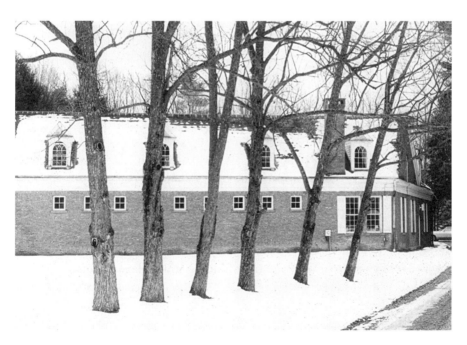

500 Route 308, Dr. George Miller's carriage house, 1892.

A broad, tree-lined alley ran between Schuyler House and the carriage house. Brick gateposts and walls were also integral to the landscape design. The Grove, residence of Colonel Philip J. Schuyler, was owned by Mrs. Mary R. Miller in 1854 and descended to Dr. George N. Miller Jr.

ARTS AND CRAFTS

10 Platt Avenue, Von der Linden House, Village District, 1928

This house was built in 1928 for Julius von der Linden, who by 1908 was a "violet king" of Rhinebeck. He had sixty-four greenhouses, many of which lined Mulberry Street running toward the fairgrounds. His business was eventually sold to the Trombini family.

This house is a particularly fine example of the popular Arts and Craft–style bungalow. It has low lines, exposed roof rafter tails, a full-width porch supported by stone and stucco columns and a prominent stone chimney. The front door with beveled plate glass and a stained-glass window are prominent exterior features of the house. The rounded river stone used to build the house was trucked in from Ulster County.[112]

READY-CUT HOUSES

"Ready-cut houses" were erected on the building site from lumber that had been cut to size and carefully fitted at the catalogue-company's mills. Everything from nails to paint, shingles and mantelpieces (except, generally, those of masonry) was shipped from the catalogue-company's mills and storehouses. All of the parts were numbered, and detailed instructions accompanied each order.[113] Aladdin began manufacturing in 1906, and Sears, Roebuck and Co. in 1908. The savings in labor costs were substantial, and many catalogue houses were built in Rhinebeck during the first third of the twentieth century. Much of the "infill" in the village—houses built on lots taken from those of earlier homes—may be traced to catalogue listings from these companies, which now may be seen on the Internet.

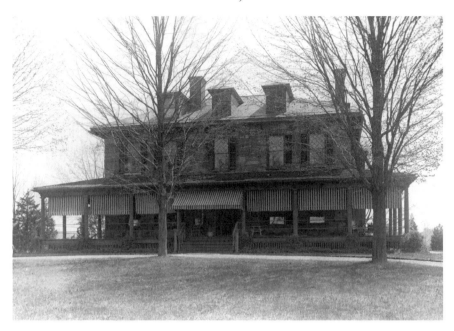

59 Ackert Hook Road, Mansakenning, 1903. *Vintage Shaffer photo.*

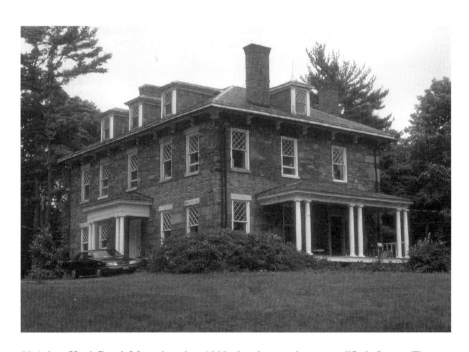

59 Ackert Hook Road, Mansakenning, 1903, showing porches as modified. *Courtesy Tom Daley.*

NEOCLASSICAL STYLE

59 Ackert Hook Road, Mansakenning, Multi-R District, 1903

Mansakenning is from the Indian name originally given to the property. The circa 1903 elegant stone house was built as a gentleman's residence by Eugene Tillotson Lynch, a great-grandson of Margaret Livingston Tillotson.

Constructed of local stone, it rises three stories in front and is a Classical Colonial Revival style. The views from the house, located high up in the hills south of Rhinebeck, are exceptional. The house is built into a hillside and is four full stories in the back. It features parquet floors and has a fireplace in every room. All windows, including the roof dormers, have diamond-paned upper sash over a single light in the lower sash. Around 1930, a large wraparound porch was removed to make way for the more fashionable, smaller versions now evident.[114] Classical columns were used on both the original porch and the current, smaller porches.

HARRIE T. LINDEBERG (1879–1959)
Harrie T. Lindeberg[115] was born in New Jersey and apprenticed at the offices of McKim, Mead & White, where he became Stanford White's personal assistant, receiving work from White's clients after his untimely death. Lindeberg was in partnership with Lewis Colt Albro (1870–1924) from 1906 to 1914, during the time when several Rhinebeck buildings were designed.[116] He featured the southern colonial porch,[117] used on several of his commissions such as the Breese House on Long Island and Albermarle in Princeton, New Jersey, and on both the Fox Hollow and Beekman Arms designs in Rhinebeck.

Fox Hollow Road, Fox Hollow Farm, Landmark District, 1909

The land south of the Landsman Kill, originally known as Millbank, became the home of Dr. Federal Vanderburgh (Linden Hill), whose Gothic house was discussed earlier. It was later part of the estate of Tracy and Alice Dows. Built in 1909, Fox Hollow was designed by Harrie T. Lindeberg from the firm Albro & Lindeberg. The main house was designed in the grand Colonial Revival style, reminiscent of Mount Vernon. It features a double-story porch with tapering Doric columns, a distinctive balustrade pattern, classical front doorway, dormers with semicircular windows and a slate roof.[118] Other buildings designed by Lindeberg on the Fox Hollow estate include the superintendent's home, the farmer's cottage, a children's playhouse and a stone stable with attached wooden coachman's house.

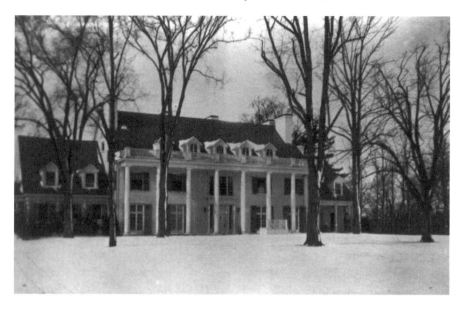

Fox Hollow Road, Fox Hollow, 1909. *Courtesy Tom Daley.*

Fox Hollow Gate Lodge, Landmark District, 1906

Harrie T. Lindeberg also designed for Tracy Dows the one-and-a-half-story stone gate lodge, near South Mill Road on the Fox Hollow estate. The east and west façades have two-part Dutch doors.

The Dowses' son, Olin, met Thomas Wolfe when they were Harvard classmates. The author visited often while working as an instructor at New York University. Beginning in 1925, Wolfe would escape to the quiet of the Dows estate, which inspired the novel *Of Time and the River.* The Dows family was the model for the Pierce family in the book, and the locale was called Rhinekill. The presence of Thomas Wolfe is felt in the Gate Lodge,

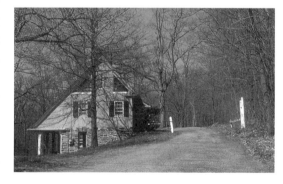

South Mill Road, Fox Hollow Gate Lodge, 1906. *Courtesy Tom Daley.*

which he used as his retreat for about six months while writing his most famous novel, *Look Homeward, Angel.*

102 Southlands Drive, Glenburn, Multi-R District, Landmark District, 1906

The Glenburn property was given to Julia Lynch Olin by her father, a grandson of Margaret Beekman Livingston. The house was originally built in 1837 but was remodeled by Harrie T. Lindeberg circa 1906–7. It became the summer home of Reverend Stephen and Julia Olin. Eventually, the property was divided between their grandchildren. Southlands was developed for Deborah Dows as the most southern part of the property while the artist, Olin Dows, retained the section still known as Glenburn.

With alterations in 1914–15 by Henry Bacon, including an east wing, and in 1938 by Theodore Dominick, the house is presently a two-story, multi-bay clapboard residence with an irregular plan including attached wings that recede on both sides from the central block. The entrance door is flanked by six-over-six windows with plain molded sills and lintels, and it is fronted by a one-story pergola, which extends across the façade. Windows on the second floor are multi-paned diamond sash over single lights. Roof dormers are six over six and have gabled roofs.

HENRY BACON

Work done by Henry Bacon seems to have resulted in the removal of Victorian detail and refinement of Glenburn as a Colonial Revival structure. Henry Bacon

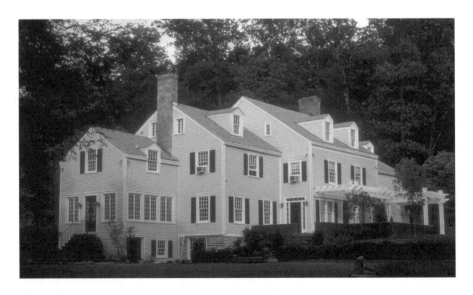

102 Southlands Drive, Glenburn, 1906. *Courtesy Tom Daley.*

is known as the designer of Chesterwood, named for sculptor Daniel Chester French. He also collaborated with French in the design for various monuments including the Longfellow (Cambridge, Massachusetts), the Layfayette (Brooklyn, New York) and the Lincoln Memorial (Washington, D.C.).[119]

6339 Mill Street, Astor Home for Children, Multi-R District, Landmark District, 1913

The Astor Memorial, built in 1913, was designed by Harrie T. Lindeberg (Albro & Lindeberg Architects).[120] However, the National Register forms claim McKim, Mead & White as the architects.[121]

The 1915 *Architecture* magazine contained pictures of the Astor Memorial, now known as the Astor Home for Children. It is located at 6339 Mill Street and is on the site of the mansion known as Bois Doré, once the country home of the Huntington family, grandparents of Vincent Astor's first wife. Bois-Doré, pictured on page 272 of the James Smith's *History of Dutchess County*, had chimneys very similar to those of the Astor Home. Further comparison with an 1896 photo in *Illustrated Rhinebeck*, produced by the Relief Hook and Ladder Company, suggest that the massing of the building and the original fenestration provided a framework for the rebuilding.

The building was designed as a two-story, H-shaped structure with slate-covered gable roof and broad cross gables. Descriptions note the brick interior end chimneys with corbelled brick pots, which pierce the east and west gable ends. Six cast-stone panels with bas-relief ornamentation are located between the banks of windows for the two stories. The façade includes a central entrance portico, flanked by two-and-a-half-story projecting bays. Lindeberg's partnership with Albro was dissolved shortly after the Holiday Farm commission.

The Astor Home was a successor for the Holiday Farm that had been established by Levi P. Morton for convalescent children on property just north of the Rhinecliff hamlet. When Bois Doré burned, Morton and Astor combined resources and arranged to provide a new, more spacious facility in Rhinebeck, named in memory of Vincent's father, John Jacob Astor IV. It now cares for autistic and emotionally disturbed children.

Mill Street, Rhinebeck, New York, Beekman Arms, Village District, 1769, 1917

The old hotel at the corner of West Market Street and Mill Streets in Rhinebeck has been operating as a tavern and hotel since colonial days, when it was a brick, gambrel-roofed structure. It was remodeled in 1917 for

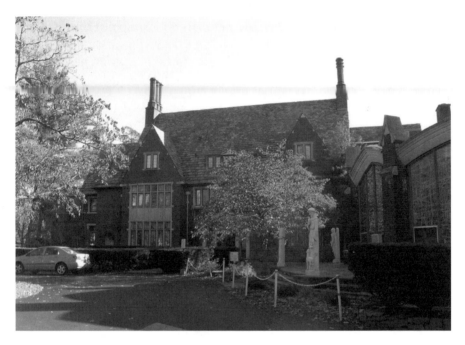

6339 Mill Street, Astor Home for Children, 1913.

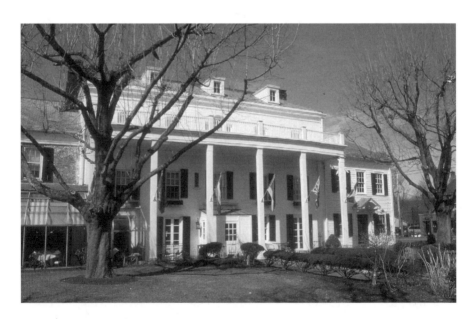

Mill Street, Beekman Arms, 1769. *Courtesy Tom Daley.*

Tracy Dows by Harrie T. Lindeberg,[122] employing design features of Fox Hollow and Mount Vernon. Thus the stone tavern that had been enlarged with Victorian additions during the later part of the nineteenth century now took on a new life with its classical façade.

In 1926, Elise Lathrop wrote:

> *The old portion of the present Beekman Arms consists of the present living room or entrance hall, into which the old hallway has been thrown, the large room on the left, and part of the present kitchen. All three rooms had old fireplaces. The one in the kitchen has been removed, but in a basement room beneath is an old oven that the present proprietor is somewhat at a loss to account for, since the room is only five feet high, and one can hardly imagine cooking being done where the cook could not stand erect. If the floor was raised, or the ceiling lowered, it must have been done many years ago. The right wing was added about a hundred years ago, the other by the present proprietor when he took the house twelve years ago [sic]. It was then in a deplorable state, having been used as a common saloon, but he has restored and added to it so as to preserve the old style, replacing the ugly double piazzas with a pillared portico across the front.*
>
> *No one who examines the thickness of the original outer wall can doubt the great age of the house. The old rafters still support the ceiling of the entrance hall; upstairs the parlor is low ceilinged, and outside swings a signboard in imitation of the old one. This inn, open for six months of the year, is Rhinebeck's only ancient hostelry still in the business.*[123]

Acquiring it in 1705, William Traphagen (1664–1739) was the first to buy land, at the center of the village of Rhinebeck, from Henry Beekman. He was a wheelwright and a blacksmith. On February 17, 1710/11, he sold one half of this land to his stepson, Arie Hendricksen.

Since the Post Road was only laid out in 1703, it is safe to assume that the Sepascot Trail, part of which is now West Market Street, was the more important route and a logical location for William's house and tavern. Later, the Post Road, leading from New York to Albany, became the most widely traveled and the Beekman Arms building was erected there in 1769 (1766?). William's son, Arent, is usually credited with the building of the Beekman Arms, but he is known to have died in 1746. Therefore, it is most likely that the builder was actually Arent's widow and her second husband, Jacob J. Kip.

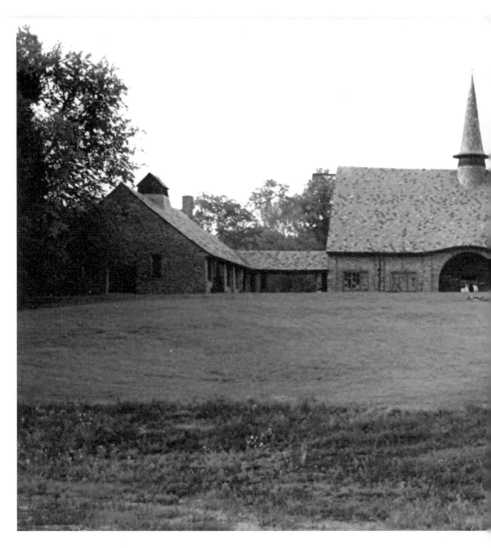

River Road, Astor Stone Barns, 1918. *Courtesy Tom Daley.*

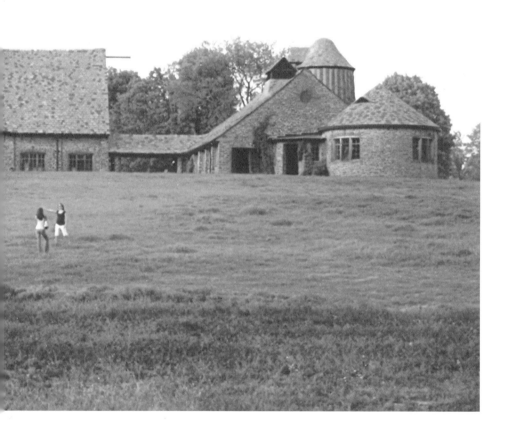

River Road, Astor Stone Barns, Landmark District, 1918

The stone barns on the Ferncliff estate, River Road, are now known as Clifton Point. They were designed by Harrie T. Lindeberg and built by Charles A. Platt for Vincent Astor, circa 1918, in the French Provincial style.[124]

HOPPIN & KOEN

Francis L.V. Hoppin (1867–1941), a native of Rhode Island, studied at the Massachusetts Institute of Technology, School of Architecture, and trained in the architectural firm of his brother Howard in Providence. He later became an apprentice in the firm of McKim, Mead & White.

In 1894, Terrence Koen (1858–1923), another apprentice of McKim, Mead & White, joined with Hoppin to begin a practice in New York City. Hoppin & Koen were well known for their country and city residences.

6436 Montgomery Street, Church of the Messiah, Village District, 1897

The building occupied by the Rhinebeck Episcopal congregation at the corner of Mulberry and East Market Streets was becoming too small to accommodate the congregation and was in need of repair. Dr. George N.

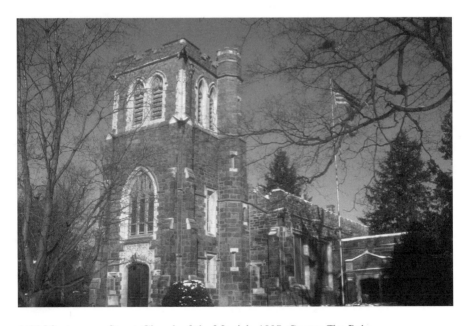

6436 Montgomery Street, Church of the Messiah, 1897. *Courtesy Tom Daley.*

Miller, owner of The Grove, and Mr. Robert B. Suckley of Wilderstein donated land on Montgomery Street for a new building. Hoppin & Koen was engaged to design the structure in 1896. The *Rhinebeck Gazette* of May 8, 1897, reported that stone for the Episcopal church would be taken from the Staley and Gay Quarry on Tator Hill. The cornerstone was laid July 7, 1897.

The stone structure is noted for its parapets and gargoyles. With Gothic, arched windows and doors, Tiffany stained-glass windows and interior wood paneling and carving, it is everything that a millionaire could desire and is evidence of the beneficence of the Mortons, Delanos, Merrits and John Jacob Astor, whose untimely death on the *Titanic* resulted in an elaborate funeral held at the church in 1912.

492 Ackert Hook Road, Rockledge, the William Starr Miller Estate, Multi-R District, Landmark District, 1904

The Rockledge main house was designed circa 1904 by Frank L.V. Hoppin of Hoppin & Koen, assisted by Whitney Warren of Warren & Wetmore, New York City. Mr. Warren was Mrs. Walter Starr Miller's brother. (Warren was also the architect of the Rhinecliff Railroad Station.)

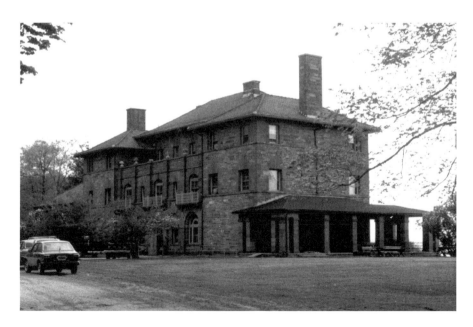

492 Ackert Hook Road, Rockledge, 1904.

The house is a three-story stone structure. The estate included a stone carriage barn and a two-story stone house built for Mr. Miller's brother, H. Ray Miller. (The Millers were brothers of Dr. George N. Miller Jr. of The Grove.)

The Italian Renaissance features include a tile roof, arched floor-to-ceiling windows and a loggia-type porch. A belt course serves to differentiate the various stories of the house.

About 1957, this property was a vegetarian resort known as Hygiology. In 1963, the Marist Fathers operated it as a seminary.[125] Day Top now uses it as a rehabilitation facility for substance abusers.

82 Kelly Street, Rhinecliff, Morton Memorial Library, Multi-R District, Landmark District, 1905

Designed in a Colonial Revival style by Hoppin, Koen & Huntington, the builder is unknown. It was designed and constructed through the generosity of Levi P. Morton, a prominent statesman and philanthropist who was elected vice president and served with Benjamin Harrison 1889–93 and subsequently as governor of New York State. He resided in Rhinebeck from 1883 until his death in 1920. This one-story brick building serves as a civic center for the community of Rhinecliff. A one-story brick wing is

82 Kelly Street, Morton Memorial Library, 1905. *Courtesy Chancellor Livingston Chapter Daughters of the American Revolution.*

attached to the south side of the main building. A full basement beneath the ell features a deeply recessed service entrance. A one-and-a-half-story Palladian-inspired window is featured on the front façade. A broad porch extends partially across the façade and is characterized by square columns, a molded entablature and box cornice.

MOTT B. SCHMIDT (1889–1977)
New York architect Mott B. Schmidt attended Pratt Institute of Technology, followed by a two-year tour of Europe, worked as an apprentice for four years and in 1912 established his own practice. He excelled at Georgian-inspired architecture, mastering the language of American Georgian Classicism at a time when many were turning to Modernism.[126] He had designed a town house for Vincent Astor before he was chosen to design Alice Astor's 1927 Georgian Revival house.

367 River Road, Marienruh, Landmark District, 1926

Vincent gave his younger sister, Ava Alice Obolensky, one hundred acres from the north part of the Ferncliff estate as a wedding present. She had Mott Schmidt design this romantic house, which was built for her and her new husband, Prince Serge Obolensky, in 1926.[127] This was only a

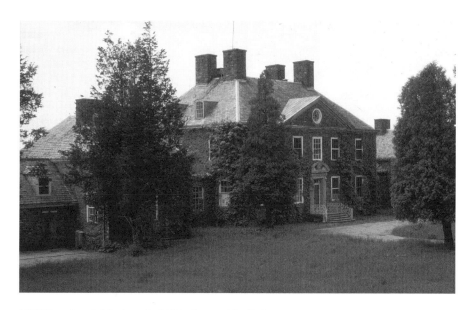

367 River Road, Marienruh, 1926. *Courtesy Tom Daley.*

few years after their father, John Jacob Astor, had died in the sinking of the *Titanic* (1912). The classic Georgian house has a five-ranked façade, central entry and hipped roof flanked by one-story wings. It shares many classical elements with Schmidt's own country house, Pook's Hill, in Bedford, New York, built in the same year and with later houses built for David Rockefeller's sister, Abby Milton, and for Martha Baird Rockefeller in Pocantico, New York.

The history of Clifton Point/Marienruh, first established by Freeborn Garrettson Jr., is discussed under the heading of the Pond Cottage, from which the original entry road led to a house near the river. This house became the home of Louis A. Ehlers, Astor's landscape designer. John Jacob Astor later acquired the property and had the Ehlers house demolished.

DAVID PLEYDELL-BOUVERIE (1911–1994)

Alice Astor's fourth husband was British architect and environmentalist David Pleydell-Bouverie. They were married on May 12, 1946, and divorced in 1952.

195 River Road, Ferncliff Tea House, 1948. *Courtesy Tom Daley.*

Eclectic Houses, 1880–1948

195 River Road, Ferncliff Tea House/Garden House, Landmark District, 1948

The Tea House, featuring a central octagonal room with side rooms, was designed for Vincent Astor's Ferncliff and was inspired by the Garden Pavilion at Versailles. The National Register description lists the designer as David Pleydell-Bouverie (1911–1994). However, plans signed by Ferenz and Taylor, dated 1948, are in the private Verrilli collection—numbers 208, 214, 229—and would seem to authenticate their involvement. The Tea House was built during Mr. Astor's second marriage with Mary (Minnie) Benedict Cushing and was used by her before their divorce in 1953. It was brick with concrete pillars, arched-top French windows and a roof balustrade around the center octagonal portion, while flanking wings provided additional rooms. Vincent and Minnie had moved into the Casino or Tennis Court House as their Rhinebeck residence, and at her insistence the Ferncliff mansion was demolished.

During the writing of this book, the Tea House has been surrounded with a new building, converting the Tea House to a dwelling.

Epilogue

In 1940, when noted author William Seabrook wrote a foreword for a pamphlet entitled *Murals in the Rhinebeck Post Office*, he described Rhinebeck from several points of view and concluded by saying, "We believe you will find not only the most beautiful but the best village this side of Paradise." Many still adhere to that same sentiment.

Architecture in Rhinebeck from World War II to the present has offered a rich variety of interesting buildings. Buildings constructed over fifty years ago are eligible for the National Register. In the future, a survey of more recent buildings should be undertaken and another book might highlight features of these buildings.

Both homeowners and the community as a whole benefit from improvements or additions that enhance, and do not detract, from their historic value. Historic buildings may be enhanced by the use of paint colors authentic for the style of building. Additions must be made in a sensitive manner to preserve the original intent of the building. The Quitman Resource Center or the Town Historian can provide information to assist with choices. Much good advice is also available on the Internet.

Rhinebeck is fortunate and proud of its historic architecture and looks forward to continuing quality in its buildings and design.

Notes

Chapter 1

1. Smith, *Documentary History*, 76–77.
2. Ibid., 286.
3. Poppeliers et al., *What Style Is It?*, 84.
4. *New York Times* obituary, August 1, 1992.

Chapter 2

5. Dutchess County Planning Board, *Landmarks of Dutchess County*, 49.
6. The records from a Kip Bible, printed in Edinburgh in 1793, were transcribed by the DAR and printed in *VI Rhinebeck Records* by Helen Delaporte of the Chancellor Livingston Chapter of the DAR. The progenitor of the family, Hendrick, came to America with his wife, Tryntje, and five children. *The Kip Family in America* lists his arrival in 1637. Femitje, a sixth child, was baptized April 19, 1643, in New Amsterdam. Hendrick, who acquired the patent in Rhinebeck with his brother, Jacob, was born in 1654. His father, Isaac, was one of twenty who were on the list of the *Great Citizenship in New Amsterdam* in 1657. Thus the family was a member of the aristocracy of the time.
7. Kip, *Kip Family*, 327.
8. The English, under Queen Anne, had provided transportation for almost four thousand people from Germany to New York in 1709. The government expected to be reimbursed by the production of naval stores, but when the project failed, the people were left to their own means of support and were glad to accept leases from large landholders in the area.
9. *Rhinebeck Gazette*, May 28, 1910; the house was occupied by Thomas Marr.
10. Kip, *Kip Family*, 335.

11. Ibid., 336.
12. MacCracken, *Blithe Dutchess*, 166.
13. Smith, *Documentary History*, 227.
14. Kip, *Kip Family*, 344.
15. J.J. Beers & Co., *Commemorative Biographical Record*, 206–7.
16. The Garrettsons were a Methodist family. Unfortunately, the church records perished when the Rhinebeck church burned in 1899, leaving no information about Freeborn Jr.'s wife or children.
17. Smith, *Documentary History*, 226.
18. The property included a brick smokehouse, an outdoor necessary (outhouse), a small workshop, chicken house, corncrib and well house. The barn was large enough to accommodate eight horses and two cows with the front side used as a wagon house, a slaughterhouse and a workshop.
19. *Rhinebeck Gazette*, April 20, 1907.
20. An advertisement found in the *Country Journal* and the *Poughkeepsie Advertiser* of Wednesday, April 11, 1787, stated that the Albany line of stages would run from Oswego Market in New York City to Lewis's in Albany every Monday and Thursday morning, providing a return trip on the following day. The stage line charged three pence per mile, which was reduced from a former charge of four pence. Passengers were allowed 150 pounds of luggage.
21. Smith, *Documentary History*, 216.
22. Jones, *Palatine Families of New York*, 203.
23. Reynolds, *Dutch Houses of the Hudson Valley*, 347.
24. John Valentine Benner from Laubenheim, Germany, was a Palatine who appears on the Rhinebeck tax lists from 1718 to 1737. His land was originally located at the site of Rokeby in Red Hook. Later, he was relocated to fertile land along what is now Benner Road. After his death, his son John assumed the property. The John Benner/Bender in Rhinebeck appears at the same time that the son, John, is in Red Hook, making the Rhinebeck John Benner a separate individual.
25. New York State Historic Marker.
26. Jones, *Even More Palatine Families*, 510.
27. Smith, *Documentary History*, 24.
28. Delaporte, "Horse and Buggy Days."
29. Jones, *Palatine Families of New York*, 231.

CHAPTER 3

30. Stevens, *Dutch Vernacular Architecture*, 29.
31. John Wigram, Map of Wurttemburger Tract for Morgan Lewis, 1802.
32. 1980 Survey Form for National Register.
33. Rhinebeck Historical Society, *A Rhinebeck Album*, 22. Photo of cornerstone.
34. Smith, *Documentary History*, 63–64.

CHAPTER 4

35. Dutchess County Planning Board, *Landmarks of Dutchess County*, 115.
36. Ibid., 115.
37. Dutchess County Historical Society, *Yearbook*, 54–63.
38. Smith, *Documentary History*, 63.
39. National Register Continuation Sheet, 8:14.
40. Crosby, "The Story of Grasmere," 25.
41. Original documents, stored in a trunk in the church attic, were donated to the Rhinebeck Historical Society and placed on long-term loan at the FDR Library in Hyde Park. The papers have been microfilmed and give details of building supply purchases, etc.
42. Quitman Resource Center (QRC), Third Annual Tour 1998.
43. Bangs, *Life of Freeborn Garrettson*.
44. *Rhinebeck Gazette*, November 27, 1879, *History of the Methodist Church and of Garretson's house*.
45. Schuyler Papers, Rockefeller Archives.
46. Rutsen's mill stood on the Landsman Kill until 1858, when it was torn down. Stones from the mill were used to build bridges over the creek near the spot where the mill had stood. The Salisbury Turnpike Bridge, now rebuilt, is on the National Register of Historic Places along with the Pilgrim's Progress Road Bridge.
47. Reynolds, *Dutchess County Doorways*, 214.
48. Schuyler Collection, S955, S953.
49. Kennedy, *Architecture, Men, Women, and Money*, 5.
50. QRC, Third Annual Tour 1998.
51. Williamson, "The Northern Approach."
52. Building Inventory Form, Nancy Todd and Neil Larson, Division of Historic Preservation, 1986.
53. 1984 Survey Form for National Register.

CHAPTER 5

54. Hamlin, *Greek Revival Architecture in America*, 15.

55. Falatko, "A Neoclassical Journey," 40.

56. Lossing, *The Hudson*, 178.

57. Kelly, *Deaths, Marriages and Much Miscellaneous*, 111.

58. *Commemorative Biographical Record*, 47.

59. Smith, *Documentary History*, 131.

60. Dutchess County Deeds, vol. 124, 30.

61. Elma Williamson, oral reminiscence.

62. Williamson, "The Southern Approach."

63. 1980 Survey Form for National Register.

64. St. Peter's Lutheran Church papers, extended loan at the Roosevelt Presidential Library, Hyde Park, "Contract with Stephen McCarty, August 1823."

65. Building Inventory Form, Nancy Todd and Neil Larson, Division of Historic Preservation, 1986.

66. Ibid.

67. Hamlin, *Greek Revival Architecture in America*, 330.

CHAPTER 6

68. Downing, "Hints to Rural Improvers," *Rural Essays*, 115.

69. Downing, *A Treatise on the Theory and Practice of Landscape Gardening*, 28.

70. Peck, *Alexander Jackson Davis*, 9.

71. Ibid., 110.

72. Ibid., 111.

73. *Commemorative Biographical Record*, 621.

74. *Wilderstein News Line*, vol. 14, no. 1, June 1999.

75. *Rhinebeck Gazette*, April 28, 1870.

76. Peck, *Alexander Jackson Davis*, 110.

77. Kelly, *Deaths, Marriages and Much Miscellaneous*, 158.

78. MacCracken, *Blithe Dutchess*, 340.

79. Ibid.

80. Morse, *Historic Old Rhinebeck*, 197.

81. Ibid.

82. Bowen, *Great River of the Mountain*, 78.

83. Phillip, *Rhinecliff, The Tangled Tale*, 63.

CHAPTER 7

84. See more about the Queen Anne phase under that heading.

85. *Rhinebeck Gazette*, February 20, 1873.

86. Delaporte, "Town Records," vol. 6, no. 50.

87. *Rhinebeck Gazette*, November 12, 1921.

88. Smith, *Documentary History*, 183.

89. Hudson River Heritage Country Seats Tour, 1998.

90. Building Inventory Form, Nancy Todd and Neil Larson, Division of Historic Preservation, 1986.

91. Kelly, *Deaths, Marriages and Much Miscellaneous*, 35.

92. The Decker family members are descendants of Jan Broersen Decker, who settled at Esopus by 1658. Records show that he was from Husum, Schleswig Holstein, Denmark. Broer Jans Decker, a son of the immigrant, moved to Livingston manor prior to 1720. Broer's great-grandson was Joshua A. Decker (1806), son of Georg A. (1778), who was son of Jurie/ Georg (b. 1754). (Information assembled by the author from page 215 and 219 of *The Decker Family* by Benton Decker; page 372 of *Coon Family* by William S. Coons; and church, newspaper and cemetery records.

93. 1980 Survey Form for National Register.

CHAPTER 8

94. MacCracken, *Blithe Dutchess*, 153.

95. Smeins, *Building an American Identity*, 103.

96. *Rhinebeck Gazette*, "Foundation going up rapidly for the Wager house," April 23, 1874.

97. *Rhinebeck Gazette*, June 19, 1883, obituary.

98. *New Yorker* cartoonist Charles Addams often depicted a house of this style.

99. *Rhinebeck Gazette*, May 13, 1875. Mr. O'Brien occupied it on the first instant.

100. *Rhinebeck Gazette*, July 17, 1876.

101. Kelly, *Deaths, Marriages and Much Miscellaneous*, 103.

CHAPTER 9

102. Phillip, *Wilderstein and the Suckleys*, 23.

103. DAR and Museum of Rhinebeck History Garden Tour, 2004.

104. Museum of Rhinebeck History, House Tour, 1997.

105. HRH Country Seats 1998.

106. MRH 1997 National Register blue form, M. Hatch.

CHAPTER 10

107. McAlester, *A Field Guide*, 319.

108. Rifkind, *A Field Guide to American Architecture*, 65.

109. Leland M. Roth, *International Dictionary of Architects*, 564–65.

110. Kay Verrilli Collection, "Tennis Court," #220–228.

111. McKim, Mead & White, *Monograph of the Works*, 65.

112. MRH 1997.

113. Massey and Maxwell, *House Styles in America*, 159.

114. HRH Country Seats 1999.

115. Lindeberg, *Domestic Architecture*, vi.

116. Zukowsky and Stimson, *Hudson River Villas*, 218.

117. Lindeberg, *Domestic Architecture*, xvi.

118. MRH 1997.

119. Ellen McClelland Lesser, Southlands, letter to Mr. Neil Larson, New York State Office of Historic Preservation (NYSOHP), December 20, 1983.

120. Lindeberg, *Domestic Architecture*, 201.

121. Based on Nancy Todd and Neil Larson, Rhinebeck Town Multiple Resource area, March 1978, perhaps the confusion arises because Lindeberg originally worked for White, who died in 1906.

122. Lindeberg, *Domestic Architecture*, 200.

123. Lathrop, *Early American Taverns and Inns*.

124. Kay Verrilli Collection, "Blueprints for Dairy Complex," #9.

125. National Register Blue Form, Rhinebeck Town Multiple Resource area, 1978.

126. Hewitt, *The Architecture of Mott B. Schmidt*, ix.

127. Ibid., Plate 12, 162.

BIBLIOGRAPHY

Baker, John Milnes. *American House Styles: A Concise Guide.* New York: WW. Norton & Company, 1993.

Bangs, Nathan. *The Life of Freeborn Garrettson.* New York: J. Emory and B. Waugh, 1832; also online: http://wesley.nnu.edu/wesleyctr/ books/0001-0100/hdm0013.pdf.

Bloom, Harold. *The Age of Innocence (Bloom's Modern Critical Interpretations).* New York: Chelsey House, 2005.

Bowen, Crosswell. *Great River of the Mountain: The Hudson.* New York: Hastings House, 1941.

Decker, Benton Weaver. *The Decker Genealogy.* Budget Book Co., 1980.

Downing, Andrew Jackson. *Rural Essays.* Edited by A.J. Downing. New York: Leavitt & Allen, 1854; also online http://lccn.loc.gov/06004590.

Dutchess County Planning Board. *Landmarks of Dutchess County, 1683–1867, Architecture Worth Saving in New York State.* New York: NYS Council on the Arts, 1969.

Eberlein, Harold Donaldson, and Cortlandt Van Dyke Hubbard. *Historic Houses of the Hudson Valley.* New York: Bonanza Books, 1942.

Gates, John D. *The Astor Family: A Unique Exploration of One of America's First Families.* Garden City, NY: Doubleday & Co., 1981.

Hamlin, Talbot. *Greek Revival Architecture in America.* London: Oxford University Press, 1944.

Hewitt, Mark A. *The Architecture of Mott B. Schmidt.* New York: Rizzoli, 1991.

———. *The Domestic Architecture of Harrie T. Lindeberg.* New York: Acanthus Press reprint, 1996.

J.J. Beers & Co. *Commemorative Biographical Record Of Dutchess County, New York: Containing Biographical Sketches Of Prominent And Representative Citizens, And Of Many Of The Early Settled Families.* Chicago: J.J. Beers & Co., 1897.

Jones, Henry Z. *Even More Palatine Families.* Rockport, ME: Picton Press, 2002.

———. *More Palatine Families.* Universal City, CA: Henry Z. Jones, 1991.

———. *The Palatine Families of New York, 1710.* Universal City, CA: Henry Z. Jones, 1985.

Kelly, Arthur C.M. *Deaths, Marriages and Much Miscellaneous from Rhinebeck, New York Newspapers 1846–1899.* Two volumes. Rhinebeck, NY: Kinship, 1978.

———. *Rhinebeck, N.Y. Eighteenth and Nineteenth Century Death Records.* Rhinebeck, NY: Kinship, 1992.

———. *Rhinebeck Road Records, Dutchess County, NY, 1722–1857.* Rhinebeck, NY: Kinship, 2001.

Kelly, Nancy V. *A Brief History of Rhinebeck: The Living Past of a Hudson Valley Community.* New York: Wise Family Trust, 2001.

Kip, Frederic Ellsworth. *History of the Kip Family in America.* Montclair, NJ: 1928.

Kennedy, Roger G. *Architecture, Men, Women and Money in America 1600–1860.* New York: Random House, 1985.

BIBLIOGRAPHY

Lathrop, Elise. *Early American Taverns and Inns.* New York: R.M. McBride & Company, 1926; also online: http://www.rootsweb.com/~nyherkim/ history/earlyamerinns.html.

Lindeberg, Harrie T. *Domestic Architecture of Harrie T. Lindeberg.* Introduction by Mark Alan Hewitt. New York: Acanthus Press, 2003

Lossing, Benson J. *The Hudson, From the Wilderness to the Sea.* New York, 1869.

Massey, James C., and Shirley Maxwell. *New York.* New York: Penguin Studio, 1996.

MacCracken, Henry Noble. *Blithe Dutchess: The Flowering of an American County from 1812.* New York: Hastings House, 1958

McAlester, Virginia, and Lee McAlester. *A Field Guide to American Houses.* New York: Knopf, 1984.

McKim, Mead & White. *A Monograph of the Works of McKim, Mead, & White, 1879–1915.* New York: McKim, Mead & White, 1915; reprint Arno Press, Inc., 1977.

Morse, Howard H. *Historic Old Rhinebeck: Echoes of Two Centuries.* Rhinebeck, NY: self-published, 1908; reprint Kinship, 1977.

Peck, Amelia. *Alexander Jackson Davis: American Archtiect 1803–1892.* New York: Rizzoli, 1992.

Phillip, Cynthia Owen. *Rhinecliff, The Tangled Tale of Rhinebeck's Waterfront: A Hudson River History.* Hensonville, NY: Black Dome Press, 2008.

———. *Wilderstein and the Suckleys: A Hudson River Legacy.* Rhinebeck, NY: Wilderstein Preservation, 2001.

Poppeliers, John C., Allen Chambers Jr. and Nancy B. Schwartz. *What Style Is It? A Guide to American Architecture.* Historic Trust for Historic Preservation. Washington, D.C.: Preservation Press, circa 1983.

Reynolds, Helen Wilkinson. *Dutchess County Doorways and Other Examples of Period Work in Wood, 1730–1830.* New York: William Farquhar Payson, 1931.

———. *Dutch Houses in the Hudson Valley Before 1776*. New York: Payson and Clarke, Ltd., 1929; reprint New York: Dover Publications, 1965.

Rifkind, Carole. *A Field Guide to American Architecture*. New York: New American Library, circa 1080.

Smeins, Linda E. *Building an American Identity*. New York: Rowman Altamira, 1999.

Smith, Edward M. *Documentary History of Rhinebeck*. Rhinebeck, NY: self-published, 1881; reprint Rhinebeck, NY: Kinship, 1974.

Smith, James H. *History of Duchess County 1683–1882, New York*. Syracuse, NY: D. Mason, 1882.

Stevens, John R. *Dutch Vernacular Architecture in North America, 1640–1830*. West Hurley, NY: HVVA, 2005.

Tietjen, Sari B. *Rhinebeck, Portrait of a Town*. Rhinebeck, NY: Phanter Press, 1990.

Zukowsky, John, and Robbe Pierce Stimson. *Hudson River Villas*. New York: Rizzoli Publications, 1985.

PERIODICALS

Crosby, Maunsell S. "The Story of Grasmere." *Year Book of the Dutchess County Historical Society*. Poughkeepsie, NY: Dutchess County Historical Society, 1929.

Dutchess County Historical Society. "1823 List of Premiums." *Year Book of the Dutchess County Historical Society*. Poughkeepsie, NY: Dutchess County Historical Society, 1928.

Falatko, Stephen. "A Neoclassical Journey." *Hudson Valley* (October 1993).

Flynn, Dale Bachman. "Finding the House of Mirth in the Hudson River Valley," *The Hudson River Valley Review* (Autumn 2006).

Wilderstein News Line 14, no. 1 (June 1999).

PAMPHLETS

Dows, Olin. *Murals in the Rhinebeck Post Office.* New York: United States Postal Service, 1939.

Relief Hook and Ladder Company. *Illustrated Rhinebeck.* Rhinebeck, NY: Rhinebeck Gazette, 1896.

Rhinebeck Historical Society. *A Rhinebeck Album, 1776, 1876, 1976.* Rhinebeck, NY: Rhinebeck Historical Society, 1976.

MANUSCRIPTS

Delaporte, Helen Reed. "Horse and Buggy Days." Rhinebeck, NY: Chancellor Livingston Chapter, DAR collections, 1935.

Delaporte, Helen Reed, ed. "Town Records." Rhinebeck, NY: Chancellor Livingston Chapter, DAR collections, n.d.

Williamson, Elma. "The Northern Approach." Collection in the Rhinebeck Historical Society.

———. "The Southern Approach." Collection in the Rhinebeck Historical Society.

INDEX

A

Ackert
 Ackert & Brown 140
 Adam 33
 P.J. 138
 William 140
Ackert House 33
Adam, Robert 56
Aladdin 150
Albro, Lewis C. 152
Ankony 28, 72
Ardagh, Kate 102
Armstrong, John, Jr. 85
Arts and Craft style 150
Ascension Sunday School 102
Asher, George Adam 42
Astor
 Alice 163
 gatehouse 126
 Home for Children 144, 155
 John Jacob 68, 101, 119, 147,
 148, 155, 161, 164
 stone barns 160
 Vincent 148, 155, 160, 165
 William B. 126
Atkins, Charles 149

B

Bacon, Henry 154
Baptist addition 141
Baptist Home 117
Barringer, John C. 68
Barringer House 68
Beach, Ira H. 42
Beatty, George D. 140
Beaux Arts 147
beehive oven 66, 118
Beekman
 Colonel Henry 25
 Henry 15, 24, 25, 26, 32, 33, 37,
 38, 42, 48, 55, 56, 63, 65, 74,
 84, 118, 157
 Judge Henry 25
Beekman Arms 16, 29, 92, 152,
 155, 157
Bell, Reverend Samuel 79
Benjamin, Asher 72
Benner, John 36, 37
Benner, John Valentine 37
Benner House 36
Bois Doré 155
Bourne, James R. 52
Bouverie, David Pleydell 165

Bowen, Croswell 99
Bowne
 Eliza 63
 Rodman 91
Brog. *See* Progue
Brookmeade 117
Brown
 Abraham 33
 Herman 33
 John 33
Brown, John (builder) 101
Brown, John C. 140
Burrell, Mrs. 114

C

Cannon, Arnout, Jr. 133
Carroll Building 121
Casino 148
Champlin, J.H. 67
Chestnut Street
 Number 19 137
 Number 25 136
 Number 31 113, 116
Church of the Ascension
 parsonage 102
 ruins 103
Church of the Messiah 160
Clifton Point 27, 28, 160, 164
commercial buildings 121
Contine, Moses 26
Cookingham
 Bill 117
 Frederick 53
 Joe 117
 Nettie 117
Cookingham House 53
Coon, Ethan A. 139
Corke, Henry 80
Cox, John, Jr. 37
Cox House 37

Croff, Gilbert Bostwick 111, 127, 128, 129
Crosby
 Ernest 57
 Maunsell 57
Cross, Dr. William 92
Crow Hill 94
Crowley
 George 107
 Mrs. E. Chase 94
 Richard 94
Crucius, George 42
Cushing, Mary B. 165

D

Davis, Alexander Jackson 89, 90, 91
Davis, Isaac 30
Decker
 Gary 140
 Robert A. 120, 139
 Robert G. 139, 140
 Roy 140
DeGarmo, James M. 123
DeGarmo Institute 123
Delamater, Henry 91, 111
Delamater House 90, 91
Delano, Laura 85, 101, 145
Delano family 161
District 11 95
District 1 Schoolhouse 90, 94
Dominick, Theodore 154
Downing, Andrew Jackson 89, 90
Dows
 Deborah 101, 154
 Olin 85, 154
 Tracy 16, 152, 153, 157
Drury, John 53
Drury House 53
Dulles, John Foster 52

Dutch door 22, 36, 42, 48, 59, 153
Dutchess Terrace
 Number 19 97

E

Eastlake style 137
East Market Street, Number 1 122
Ehlers
 Hans Jacob 126
 Louis A. 126, 164
Ellerslie
 1814 73
 1885–88 143
Elmwood 102, 113
Elseffer, Ludwig 48
Emigh, Nicholas 33
Emighyville School 75
Esselstyn, George 113
Evergreen Lands 145
Evergreen Lawn 106

F

Falatko, Stephen 71
Feller, Philip 43
Feller House 42
Ferenz and Taylor 165
Finck, A. 97
Four Sisters 120
Foursquare style 139
Fowler, Orson 118
Fox Hollow 33, 68, 91, 152
 Farm 152
 Gate Lodge 153
Fraleigh, Stephen 32, 38
Fredenburg 34. *See also* Van
 Fradenburg
Frost
 Benson 53
 Law Office 53

G

Gables 107
Gardner, John 82
Garrettson
 Catherine Livingston 15
 Freeborn, Jr. 28
 Freeborn T. 28
 Mary 15, 59, 76, 95
 Reverend Freeborn 28, 37, 59
Gaustavino tile 148
Glenburn 154
Good Shepherd, Church of the 98
Good Shepherd Catholic Church
 111
Grasmere 34, 36, 50, 56, 89, 106
Greek Revival 71
Grove, The 62, 150
Gurnell, Dewitt 17, 57

H

Haen, Chester 79
Hainer. *See* Hayner
Hamlin, Talbot 87
Harrison
 Benjamin 162
 Mary J. 91
Hayner, Robert 49
Hayner House 49
Heermance
 General Martin 102
 Martin 101, 113
Heermance House and Law Office
 101
Hendricksen, Arie 157
Hermanella Island 75
Hill, Edwin 79
Holiday Farm 155
Hoppin & Koen 160, 161
Hoppin, Francis L.V. 160, 161
Hoppin, Koen & Huntington 162

Hunt, Richard Morris 143, 144
Huntington family 155
Hygiology 162

J

Jackson, Elihu 91
jambless fireplace 23, 26, 35, 45
James
 Augustus 62
 Henry 62, 97
 John B. 62, 90
Jones, Elizabeth S. 96, 111
Judson Building 122

K

Keating, John 45
Kelly, William 73, 74, 111, 143
Kiersted, Dr. Hans 113
Kilmer, Herman 75
Kip
 Abraham 26
 Abraham Kip House 26
 Henry 24, 26
 Henry J. 72
 Isaac 27
 Jacob 24, 26, 27
 Jacob J. 157
 Jacob Kip House 26
 John 26, 27
Kip-Beekman-Heermance 22, 24
Kirchehoek 48

L

Landon writing school 37
Landsman Kill 29, 30, 33, 38, 39,
 62, 68, 90, 152
Latrobe, Benjamin 73
Latson
 Dr. Frank 111
 Henry 111, 126, 127, 129

 Peter 111
Latson Building 121
Lawnknoll 75
Law Office
 Number 6406 Montgomery 85
Leacote 93
Lewis, Morgan 66, 116
Lindeberg, Harrie T. 16, 144, 152,
 153, 154, 157, 160
Linden Grove 97
Linden Hill 90
Linwood 62
Linwood Hill 97
Livingston
 Janet 50
 Margaret Beekman 55, 154
 Maturin 73
 Mrs. Walter T. 118
 Peter R. 56
Livingston Street
 Number 41 137
 Number 48 135
Lorillard, Dr. George 119
Lorillard House 119
Lynch, Eugene T. 152
Lyndhurst 93

M

Mansakenning 152
mansard roof 31, 32, 57, 73, 123,
 126, 127, 128, 129
Maples, The 67
Marienruh 163
Market Street
 Number 110 East, Stephen Mc-
 Carty 78
 Number 122 East, Reverend Bell
 79
 Number 55 East, John McCarty
 78

Number 87 East, Edwin Hill 79
Marquart, Johannis 53, 66
Marquart House 66
Marquot. *See* Marquart
McCarty
 Daniel 77
 Stephen 76, 77, 78, 79, 82, 83
McKim, Mead & White 149, 152
Meadows, the 93
Meadowsweep 80
Merrit family 161
Merritt
 Douglas 93
 George 93
Methodist 15, 37, 39, 59, 75, 76,
 79, 99
 Hillside 101
 Mount Rutsen 101
 Riverside 99
 Village 75
Miller
 Dr. George N., Jr. 64, 149, 161,
 162
 H. Ray 162
 Mary Regina 63, 102, 122, 150
Miller Schoolhouse 95
Mills
 Ogden 147
 Ruth 66
Milton, Abby 164
Mink, William 86
Montgomery
 General Richard 50
 General Richard House 50
 Janet Livingston 15, 51, 56, 89
Montgomery Street
 Number 6435 92
 Number 6439 84
 Number 79 118
Moore

 J.W. 106
 Philip 68
Moore House 103
Morse, Howard 121, 139
Morton, Levi P. 143, 147, 155, 162
Morton family 161
Morton Memorial Library 162
Morton Schoolhouse 94
Moul, Jacob 64
Moul's Tavern 64
Mulberry Street
 Number 23 135
 Number 3 98

N

Near. *See* Neher
 M.R. 49
Neher, Frans 48
Neher-Elseffer House 18, 48
Norman Gothic 97

O

O'Brien
 John 126, 129
 Thomas 37
O'Brien House 129
O'Dell, Andrew 80
Obolensky, Serge 163
octafoil windows 118
octagon 165
Olin
 Julia 101
 Reverend Stephen 154

P

Palatines 9, 18, 21, 25, 30, 33, 37,
 38, 43, 48, 51, 53, 65, 68, 83,
 115, 118
Palladian window 55, 57, 65, 163
Palladio, Andrea 55

Parthenon 82
Peter Pultz House 52
Pier
 Jan 30
 Tunis 30
Pier House 30
Pink family 116
Platt, Charles A. 160
Platt Avenue, Number 17 139
Pond Cottage 27, 28, 164
Pope, John Russell 144, 145
porte-cochère 140, 146
Potter, Edward Tuckerman 99,
 101
Progue, Matthias 38
Proper, Robert 115
Pultz
 G. 48
 John 116
 Michel 48, 116
 Peter 52
Pultz House 48

Q

quatrefoil windows 106, 142
Quick, Smith 114
Quick House 114
Quitman, Reverend Frederick 58,
 59
Quitman House 58

R

Radcliff
 Joachim 35
 M.E. 102
Reformed
 German 48
 Rhinebeck 15, 77, 82, 84
Reformed Church 84
Renzelver 136

Reynolds, Helen W. 22, 34, 45
Rhinebeck and Connecticut Rail-
 road 126
Rhinecliff Episcopal Church 103
Rhinecliff Hotel 98
Rhinecliff Railroad Station 147
Rider, Albert L. 126, 129
Rider House 126
Ritch, John Warren 110
Rockefeller
 David 164
 Martha B. 164
Rockledge 161
Roosevelt, Franklin D. 26, 145
Ruppert, Jacob 62
Rutsen
 Catherine 63
 John 63
 Sarah 63
Ryan
 Senator Allan 72
 Thomas Fortune 72

S

Saltford, George 139
Sands
 Grace 94
 Robert 63
Sands House 68
Savage, Reverend Thomas 102
Schaad
 bakery 66
 Jacob 66
Schalk, Ruppert 62
Schell, Christian 138
Schell House 137
Schmidt, Mott B. 163
Schryver
 G.W. 106
 Hazel 136

Jacob 56
Schuyler
 General Philip 63
 Philip 56, 63
Schuyler House 62
Scott
 Henry L. 146
 Robert 79
Sears, Roebuck 150
Second Empire style 73, 106, 123
Sepascot 24, 26, 29, 30, 59, 115, 157
Shingle style 140
Sipperly, Johannes 118
Sipperly Lown Farm 118
Skidmore, Henry 107
Smith
 Edward M. 127
 James 155
Smith House 127
South Street
 Number 15 138
 Number 49 107
 Number 51, Livery-Frazer 80
Spanish Revival 146
St. Joseph's Catholic Church 99
St. Peter's Evangelical Lutheran.
 See Stone Church
Staatsburgh House 74
Stacks, Myron 117
Staley & Gay Quarry 161
Starr Institute 122
Steenberg. See Van Steenberg
Steenberg Tavern 22, 34
Steen Valetje 43
Stein, Conrad 146
Stone Church 83
Stonecrest 140
Strawberry Hill 42
Styles, Edwin 53

Suckley
 Daisy 134
 George 63
 Katharine 75
 Robert B. 133, 161
 Rutsen 86, 101
 Thomas 59
 Thomas H. 110

T

Tea House 165
Teal. See Teil
Teel, Joseph 28
Teil
 Ananias 51
 Andrew 51
Teil House 51
Teller, John I. 113
Thaw, Harry K. 148
Third Lutheran Church 76
Thompson, William 117
Tietjen, Herman 53
Tillotson, Thomas 62
Timpson, Louise 57
Toole, Kenneth 56
Traphagen, William 157
Traver
 Albert F. 42, 117
 Alice 30
 Bastian 30
 Chester 42
 Gilbert 75
 J.E. Traver Farm 68
 J.W. 49
 John H. Farm 116
 Nicholas 30
 Number 371 Wurtemburg Road
 117
 Peter 30
Traver House 29

Tremper, Jacob 30, 31
Trombini 150
turnpike 29, 52, 71, 75, 76

U

Upjohn, Richard 73, 99

V

Vanderberg Cove 90
Vanderburgh, Dr. Federal 62, 90, 152
Vanderlind Building 121
Van Fradenburg
 Fredenburg House 33
 Van Vradenburg Farmhouse 85
Van Steenberg, Benjamin 35
Van Steenberg Building 121
Van Vradenburg 85, 86
Van Wagenen 59
Vaux, Calvert 110
Veitch, George 95, 96, 97, 98, 99
village firehouse 122
violets 139, 150
Von der Linden 150
 Julius 139
Von der Linden House 150
Von Thum 85
Vradenburg. *See* Van Fradenburg

W

Wager, Ambrose 111, 118, 128
Wager House 128
Wainwright
 Charles S. 93
 William P. 93
Warner
 Anna 76
 Susan B. 76
Warren & Wetmore 147, 161
Warren, Whitney 161

Weaver, Leslie 115
Wells
 Caroline 114
 Eugene 114
Westfall family 65
Westfall House 65
Wharton, Edith 97, 109
Whispering Pines 146
White
 McKim, Mead & White 147, 148, 155, 160
 Stanford 64, 147, 152
White Corner 138
Wigram, John 51
Wildercliff 59, 95, 110
Wilderstein
 1852 110
 1888 133
Williams Farmhouse 87
windmill 82
Wolfe, Thomas 153
Women's Exchange 85
Wurtemburg 30, 37, 38, 39, 42
 St. Paul's Lutheran 82, 83
Wurtemburg Tract 38
Wyndcliffe 95, 96

About the Author and
the Photographer

Nancy V. Kelly's interest in local history developed as she grew up at Sepascot Home Farm in Rhinebeck. She is a graduate of Cornell University with a major in education and has served as Rhinebeck Town Historian since 1997. She is the author of *A Brief History of Rhinebeck* and is registrar of the Rhinebeck Chapter of the DAR; she is also a member of the Dutchess County Historical Society, the Dutchess County Genealogical Society, the Rhinebeck Historical Society and the Palatine Farmstead committee. She is chairman of the Consortium of Rhinebeck History, a group of the local historical organizations seeking to establish and maintain a database of archival material and provide a local history center at the Starr Library.

Nancy and her husband, Arthur Kelly, founded Kinship in 1968, writing and publishing genealogical and historical books. In recognition of their work, they were 2007 recipients of the Helen W. Reynolds Award from the Dutchess County Historical Society.

Tom Daley was raised on Astor's Ferncliff estate in Rhinebeck, where his father worked. He grew to have an appreciation of the Hudson River and local history, including architecture and the river families. During his working life, Tom lived in Gardiner, New York, and was employed at National Cash Register (NCR) in Newburgh, New York. Photography

became a consuming hobby. Over a long life, his work contains a volume of photographs with impressive significance to historians on both sides of the mid-Hudson River. He is well known for giving architectural talks to many area groups, his Elder Hostel programs and for his series on local public television. He is a member of the Rhinebeck Historical Society and the Episcopal Church of Regeneration, Pine Plains, New York.

Visit us at
www.historypress.net